LONDON : HER MAJESTY'S STATIONERY OFFICE

© Crown copyright 1985
First published 1985

ISBN 0 11 300000 6

Designed by HMSO Graphic Design

ACKNOWLEDGEMENTS

The Royal Commission is grateful for permission to
reproduce photographs in the National Monuments Record
the copyright of which is held by:
B.T. Batsford Ltd.
Central Electricity Generating Board
Raymond H. Hayes
Howarth-Loomes Collection
Oxfordshire County Libraries
Royal Institution of Cornwall
Staffordshire County Council

EDITORIAL NOTE

The groups of letters and numbers in each photograph
caption are the National Grid references for the building or
site. An explanation of the system may be found on the
Ordnance Survey Landranger (1:50,000) Series of maps.

Printed in the UK for Her Majesty's
Stationery Office by W.S. Cowell Ltd.
Dd736291 C50 7/85

PREFACE

PUBLIC awareness of the decline of traditional industry has been sharpened in recent years; concern about England's industrial future is discussed daily. Yet, in an historical perspective of millennia, it seems of the very essence of industrial development that individual industries fall even more certainly than they rise. There is, therefore, an archaeology of industry, represented by redundant plant and other remains, just as surely as there is a history of industry from documentary evidence. The story of industry begins, however, long before the first written records.

The International Council of Monuments and Sites declared 18 April to be International Day of Historic Monuments and Sites and invited interested bodies to inaugurate it in 1984 in some appropriate manner. The Royal Commission chose to mount a modest exhibition illustrating entirely from its public archive, the National Monuments Record, facets of industrial history in England as represented by both surviving, tangible remains and the visual records made of them. The interest of the latter, brought to light in preparing the exhibition, was such that the desirability of presenting it to a wider public was immediately apparent. Meanwhile, the Royal Society for the Encouragement of Arts, Manufacture and Commerce had announced that 1986 was to be Industry Year and we decided to contribute in some small way. The idea of a picture book based on the exhibition naturally fused with the suggestion of publishing it in time for Industry Year. The actual date of publication, in August 1985, was arranged to coincide with an RCHM exhibition on the industry theme at Sheffield Industrial Museum.

Though of such mixed parentage, this book follows the policy of my Commissioners already represented by the six smaller picture books, published 1981-4, based upon collections in the National Monuments Record. This one has a longer text, written by my colleagues, Stephen Croad, Keith Falconer and Nicholas Cooper; the whole has been welded together with a selection of photographs by Priscilla Boniface as editor. The text, however, is but commentary on the photographs which constitute the core of this book. Some accidentally include industrial remains but most were deliberately taken as a record, either for historical purposes or as a view of contemporary scenes. Their value to students and scholars increases as time passes and particularly as the very memory of wholly-defunct industries begins to fade. It is one thing to bemoan, or even delight in, the disappearance of individual buildings or installations, but quite another, at least from the historian's point of view, when a whole industrial process becomes redundant. With it can pass away the communities, even a distinct way of life, which both supported it and were created by it.

As the national economy changes from one to a large extent based upon labour-intensive heavy industry, the need and the opportunities to record both the processes of change and their consequences in terms of relict plant and even whole landscapes fall firmly within the remit of this Commission; yet the demands far exceed its actual resources. The record has to be made locally and can often only be made through local interest. In demonstrating in this book the nature of the material that is already in the National Monuments Record, and the sort of photographic records that pioneers have already made, we hope very much to encourage others to supplement the relatively small contribution that we can make.

Many of the lessons of how to go about this task are implied in this selection of photographs. Furthermore, a professional approach to the whole question of photographic recording, applicable in this field as well as elsewhere, has already been made available in another of our books, *Photographing Historic Buildings for the Record* (HMSO 1983). It is intended to encourage

anyone with a good camera. As it stresses, the making of a record, however meritorious in itself, can nevertheless be little more than self-indulgence unless the results are deposited in a public archive. Only then can the results benefit those to whom the scenes we see at the moment will quickly be as remote visually as is the evidence now of man's earliest industrial activities in this country. Whether the archive chosen be at national or local level does not particularly matter; it is the act of deposition which is important. If the camera had been available in the 17th and 18th centuries, for example, how valuable its products would have been to us in grappling with many unanswered questions about the origins of much industrial development and about the growth of industry during the reign of George III.

At a time when changes of both industrial decline and generation are all about us, it does not take much imagination to realise that records made now can hardly fail to be of value for all sorts of purposes in a relatively short time. We can but hope that this modest illustration of what has been photographed in the past, and of the contemporary value of such photographs, will be of general interest. Should it inspire at least a few to apply their cameras to the making of a record, not only of the past but also of change in the present, many will later have cause to thank their efforts.

P J FOWLER
Secretary

INTRODUCTION

OLD photographs of daily life, of the streets and towns with which our ancestors were once familiar, are among the most evocative records of the past. Yet early contemporary photographs of industry, showing people's work places and the transformation brought about by the industrialization of the English landscape, are fairly uncommon. The reasons are not hard to find. Whatever the wealth and the scientific advances brought about by industry, and however attractive the dreams of a future Utopia when its fruits had become universally available, most people in the 19th century found industry and the places where it was carried on, grim and forbidding.

In the 18th century tourists had wondered at the forges of Coalbrookdale and at Richard Arkwright's mills at Cromford, along with the beauties of the Severn valley and of the Derwent gorge at Matlock. To satisfy their curiosity, the first engravings of Coalbrookdale were published in 1757. A few painters, too, had been attracted by the effects of science and industry: Joseph Wright of Derby painted the gleam of a blacksmith's forge and the candlelight on the intent faces of children as they watched the workings of an air pump. De Loutherbourg painted the glow of the Coalbrookdale furnaces, lighting the night sky, and later Turner was to record the fire and flash from a speeding railway train. In the early years of the Industrial Revolution people were not yet overwhelmed by the sheer, vast, depressing gloom of much of industrialized England.

By the middle of the 19th century, when photography was first finding a fair number of practitioners, a less romantic attitude to industry was well established. Disraeli's Marney (in *Sybil*, 1845) and Dickens's Coketown (*Hard Times*, 1854) fairly express the popular view of the great industrial town as a place of unrelieved toil and grime. Few artists painted scenes of work and those who did, such as Ford Madox Brown (*Work*, 1862-5) and John Brett (*The Stonebreaker*, 1856)

did so to make a moral or a social point rather than out of any interest in the activity carried on. Even W.P. Frith, the greatest Victorian painter of social realism, only approached an industrial subject once (*The Arrest*, 1862) and then only because the scene, Paddington Station, provided a setting for a cosmopolitan mix of humanity. Between nostalgia for an idealized past and the yearning for a golden future, few beside the industrialists themselves were pleased with things as they then were.

Photography, the result of research into optics and chemistry made during the 18th century, was to transform the image of industrialization for posterity. Thomas Wedgwood, a son of the potter Josiah, first demonstrated the possibility of photography but was unable to fix his images. Sir Humphry Davy published his experiments in 1802. In 1826 Nicéphore Niépce, a French amateur scientist, made the first successful photograph and after his death his partner, Louis Daguerre, a theatrical designer, invented the first photographic process, announced on 7 January, 1839. His daguerrotype produced a direct positive on a silvered copper plate. In England, William Henry Fox Talbot had already succeeded in producing permanent photographic negatives. He published his discovery on 31 January, 1839 and patented his process as Calotype in 1841. This method produced a paper negative from which any number of positives could be made, while the daguerrotype remained a unique image, preferred by professional photographers who concentrated on portraiture. It is scarcely surprising, in view of the contemporary attitude towards industrial scenes, that those who were prominent in the early days of the medium very seldom depicted industry. There were also practical reasons why they might have found such subjects difficult. Long exposures with the waxed paper negatives of the 1840s and 1850s made it impossible to record moving objects, and when the introduction of the wet-plate collodion

process (invented by F.S. Archer in 1851) speeded up exposure times, it is likely that the tacky glass plate negatives were difficult to use in dusty or smoky environments.

Yet despite this, a few photographers did record industrial scenes. The most important of those who might be described as topographical photographers, were to some extent free of the ambition to regard photography as a fine art; rather did they see it as a tool for the accurate recording of their neighbourhood or field of interest. The great majority of such photographers still avoided industrial subjects (there must be a hundred Victorian photographs of ruins for every one that shows a textile mill), but details that now give us valuable information on industrialization sometimes, by accident rather than by design, crept into photographs taken with another purpose. So there are dockside installations, for instance, in a very early photograph of Bristol by Fox Talbot, and Thames steamers and their wharves in views of Waterloo Bridge by Roger Fenton. Talbot was unusual among pioneer photographers in his interest in modern architecture; his photographs of Brunel's short-lived Hungerford Suspension Bridge and of the massive scaffolding around the base of Nelson's Column, then building, might almost be regarded as the first views of industrial subjects were it not that he himself would probably not have thought of them as such.

Roger Fenton, famous for his photographs of the Crimean War, was official photographer to the British Museum from 1854-8, advised the Museum when it set up a Photographic Department in 1853, and took record photographs of items in the collection. He also began photographing historic buildings in London, sometimes showing them in the process of change. For example, Fenton photographed the gatehouse of Lambeth Palace with the Palace of Westminster visible in the background, its clocktower still incomplete, and the 18th-century Westminster Bridge in scaffolding prior to demolition (c.1857).

Talbot and Fenton were innovators who have received attention from the historians of photography. As yet, however, such historians have not turned their attention to any great extent to the amateurs who followed in the pioneers' footsteps, though it is among the photographs taken by such people, now for the most part unknown and their pictures dispersed, that some of the earliest industrial scenes are to be found.

One such figure was Samuel Smith, a timber merchant of Wisbech who took up photography in 1852. His views of the area survived together as an identifiable collection long enough for them to be acquired by the local museum and for their historical value to be recognised. They show local churches, streets, houses and landscape; in recording a rural neighbourhood with its small-scale industrial structures Smith was perhaps free from the revulsion felt by many of his contemporaries towards great industrial complexes. His photographs include shipping on the busy River Nene, new quays and an iron bridge, a scrapyard and a steam piledriver, a pumping station and windmills. They are a remarkable record of the way in which during the mid-century both industrialization and mechanization were slowly finding their way into areas previously untouched by them. Smith was an amateur and it is not easy to know whether he was an isolated or a typical figure; but from the chance survival of comparable photographs from many other parts of the country it is almost certain that others at that time shared a similar interest in recording local scenes.

Topographical photography as a serious commercial business began in the 1850s and 1860s with views (often taken for the stereoscope) mainly of tourist attractions: castles, cathedrals, the historic streets of old towns, picturesque cottages, the seaside, and occasionally (when an event sufficiently captured the public's fancy) of a spectacular scene such as the launch of the *Great Eastern* in 1858. Some who began their careers then, such as Francis Frith and George Washington Wilson of Aberdeen, went on to found large and successful businesses, and their sepia photographs of holiday scenes are familiar in all photographic scrap-books of the later 19th century. (Frith's firm eventually turned to producing picture postcards and continued in business until 1971.) It was the popular market

however, that determined the subjects taken by such firms, and though an industrial feature might appear as a cast-iron seaside pier or a mill in the distant background, holiday-makers did not wish for views of the work places that they had left behind.

Other photographers who produced images of more than local interest include James Hedderley in Chelsea, Hugh Owen of Bristol, Frank Sutcliffe of Whitby, and H.O. Thompson of Newcastle. By the end of the 19th century every town had at least one commercial photographer recording the local scene but much of their work, if it survives, has become anonymous. Henry Taunt of Oxford, active between 1868 and his death in 1922, must be typical of many now unknown and forgotten, their photographs dispersed and only haphazardly preserved. Taunt catered for visitors to Oxford and to the surrounding countryside: the bulk of his views are of the Colleges, of village churches and of picturesque streets. His work, however, shows another aspect of the provincial photographer's activities which might be described as 'current-event photography': as well as the recurring demand in a university town for college and sporting groups, before the days of local illustrated newspapers there was also a demand for records of interesting events. These might include industrial subjects such as the floating-out of a new span for a railway bridge or riverside fixtures half-submerged by a flood of record depth. Taunt's own love of boating led him to visit and record stretches of canals, such as the Thames and Severn, already in decay, but photographs such as these formed only a tiny proportion of the work of a man who was, first of all, a competent and representative provincial photographer.

Like that of any such photographer, Taunt's work was divided between photographs taken in the hope that someone would buy them and those taken on commission. While we know too little about the circumstances in which many early surviving photographs were taken, many of the earliest photographs of industry and its products were certainly taken on commission. Views by Claudet exist of the Palm House at Kew during the course of its construction in 1847, presumably as a progress record of the erection of an innovative building. Photographs were taken of a number of the exhibits, many of them industrial, at the Great Exhibition of 1851, and published catalogues of the 1862 Exhibition were illustrated with photographs. From the beginning the South Kensington Museum, later the Victoria and Albert, had a resident photographer, Charles Thurston Thompson, and the construction of its first buildings, made of prefabricated cast iron and nicknamed the Brompton boilers, was photographed in detail during 1856. Manufacturers began from the 1860s to commission photographs of their premises and pictures of their products as the basis for engraved letter-heads or for advertising. New civil engineering works, like the excavations for the Metropolitan Railway and the building of St Pancras Station were now recorded. Large companies might even have comprehensive surveys of their works carried out, as the Great Western Railway did at its Swindon workshops in the 1870s. It must have begun to occur to those who commissioned such photographs that there were a number of purposes, both present and future, that surveys of this kind could serve. It was in response to a commission from Charles Early, a Witney blanket maker, that Henry Taunt photographed in the 1890s every process in their manufacture from shearing the sheep to drying the finished product; his record also included views of the interior of mills with machinery and workers. In response to a request from Frank Cooper, he photographed ranks of girls chopping oranges to make into marmalade and men stirring the boiling vats.

The *Illustrated London News,* founded in 1842 'to keep continually before the eyes of the world a living and moving panorama of all its actions and influences', was illustrated with wood-engravings, increasingly taken from photographs commissioned for the purpose, and industrial scenes often featured in its pages: colliery pit disasters, ironclads on their launching slips, the opening of a new dock, the completion of a new railway terminus, or the construction of a giant steam hammer. Just as the immense popularity of the 1851 and 1862 Exhibitions had shown that

enthusiasm for the products of industry could be divorced from people's feelings about the sources of its production, so the illustrated magazines and popular books about industry comfortably distanced their readers from the places shown while assuring them of the continuance of commercial progress.

It is in the nature of commercial photography, however, that once it has served its purpose it is likely to be discarded. Businesses of long standing, such as railway companies, may retain old photographs in their archives, but the records of shorter-lived firms are unlikely to survive. Views taken for magazines seem generally to have been destroyed once they had been published and privately commissioned views could be lost with the papers of the person or business that commissioned them. Little is known as yet about the uses of photography by other concerns, but only a small proportion of early commercial photography probably still exists.

In 1875 the Society for Photographing Relics of Old London was founded, prompted by the imminent demolition of the 17th-century Oxford Arms, a galleried inn at Warwick Lane, near St Paul's. Henry Dixon and Alfred and John Bool made record photographs of this and many other historic buildings. The increasing devotion to systematic recording and a more professional approach to antiquarian studies led to the foundation of a number of new bodies, using photography for record and illustration. Following in the footsteps of the earlier society, the Survey of London published its first volume in 1896. The Victoria County Histories commenced publication in 1904. Three national Royal Commissions on Ancient and Historical Monuments were created in 1908. Though there was perhaps no conscious effort to record industrial subjects in their surveys of monuments, they were not deliberately excluded. Inventories of the English Royal Commission have increasingly included industrial monuments, from a post-mill at Brill, then still in everyday use, in the South

Buckinghamshire *Inventory* of 1912, to a bell foundry and an 18th-century loomshop in the Salisbury volume of 1981. The photographs that illustrate this book are from the collections of the National Monuments Record, a public archive which is part of the Royal Commission on the Historical Monuments of England.

Photographic archives now exist covering all fields of specialized interest; the ready availability of photography has meant that most researchers, whatever their interest, use a camera or collect photographs. In the area of industrial history the amateur photographer has become one of the greatest benefactors of official archives. The taking and survival of industrial photographs and the bringing of them to the attention of the National Monuments Record, are largely a matter of chance, but an increasing interest in industrial archaeology has recently resulted in important bequests to the Commission's record. The private collections of Simmons and Muggeridge, who photographed wind and water mills, and the astonishing series of photographs of railway stations made by the late Rev. Denis Rokeby of Mundford are outstanding examples. Similarly a collection of photographs of Cornish mining in the 19th century made by J.C. Burrow, now the property of the Royal Institution of Cornwall, came to the Record's notice through personal contacts. Professional photographers with a private interest in the subject have also made important contributions, among them Sidney Pitcher, Hallam Ashley and Eric de Maré.

The following photographs are but a small selection from what is now a large national collection. They are arranged here thematically although drawn from a wide variety of sources which have become available during the first century or so of photography. While illustrating particular industries and processes spanning five thousand years, they also make the point that today, in the age of the film and video camera, there remains a secure role for the percipient still photograph as an historical record.

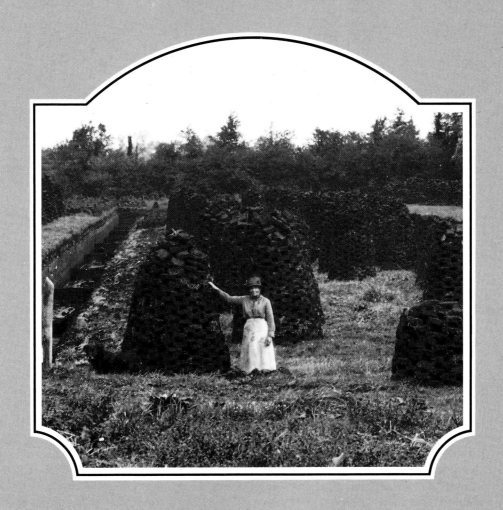

RURAL AND AGRICULTURAL

PEATFIELD, ASHCOTT HEATH (ST 4439), ASHCOTT, SOMERSET

LMS Collection 1921

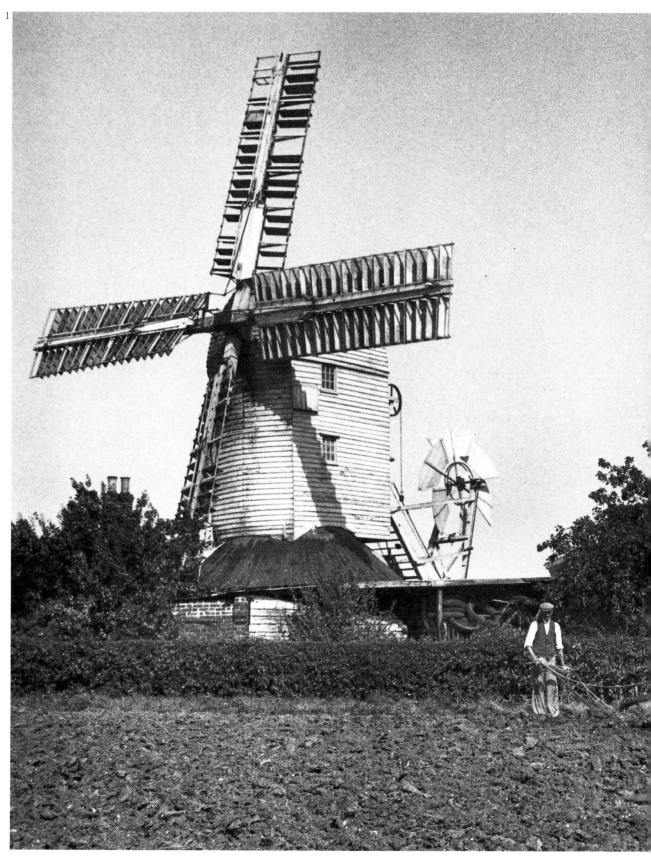

THE milling of grain and the conversion of cereals and fruit into alcoholic drink were amongst the earliest processes to pass into the control of specialist producers and be mechanized. There is no certain evidence in England of prehistoric mechanization but during the Roman period both animals and water power were exploited to power machines. Anglo-Saxon mills may have borne little resemblance to their Roman predecessors; archaeological evidence, from excavated sites such as at Tamworth, indicates that Saxon mills may have been driven by horizontal waterwheels, whereas Roman mills are assumed to have had vertical waterwheels. The Domesday survey of the late 11th century gives a vivid picture of the extensive use of water power in England. The commissioners recorded a total of 5,624 watermills in the counties they covered and, of the 9,250 manors in the inventory, more than one third had one mill or more. Yet despite remarkable concentrations such as on the River Wylye in Wiltshire, where there were thirty mills along ten miles of river, no actual remains of a Domesday mill have been identified.

The first recorded references to windmills in England were in 1185 at Temple Newsam and Weedley in Yorkshire and the technology may well have been brought back from Arab lands by the Crusaders. The earliest form was the post mill in which the whole body of the mill was turned to face the sails to the wind. Although fixed towers with moveable caps were introduced in the 15th century, post mills survived, despite their technical inferiority, alongside tower mills [1].

1 WINDMILL (TM 351695), MILL HILL, PEASENHALL, SUFFOLK

The post mill on the left of this photograph was built in 1803 and was owned by members of the Cole family from at least 1855. Its four patent sails were shortened by John Wesley Cole after one of them struck and killed a girl. In 1881 he bought and re-erected at Peasenhall a smock mill from Cransford, about 4 miles (6.5 km.) away. The rebuilt stump, with its ogee cap, appears on the right of the photograph. This no longer worked by wind power, but was steam driven and continued in use until the late 1970s. The post mill was dismantled about 1951.

H.E.S. Simmons 1935

IN low-lying coastal areas where the gradient of streams was too slight to provide sufficient power, the sea was harnessed by impounding high-tide water behind large dams. The surviving tidemill at Woodbridge in Suffolk is the descendant of a mill mentioned in the 12th century.

The impressive extent of the application of power to medieval milling was not just the product of technological progress. The milling soke, which gave landowners sole rights over their tenants' milling, had caused the prohibition and destruction of domestic handmills. It long outlived the political organization that had introduced it and it operated, albeit in an increasingly diminishing form, until the 19th century in isolated instances [2]. Steam power was applied to corn milling at the end of the 18th century. The huge Albion Mill of 1784 at Southwark, with cast-iron millwork driven by two Boulton & Watt steam engines, was the forerunner of a new breed of large mills sited with regard to navigable waterways, or, somewhat later, railways. The introduction of rollers for milling late in the 19th century allowed even larger mills to be built, thereby encouraging further the movement of milling to port locations where, after the repeal of the Corn Laws in mid-century, imported grain had increasingly been ground [3].

2 WATER-MILL (SU 903438), ELSTEAD, SURREY

This mill on the River Wey dates from the mid-18th century, but there has been a mill on the site since the 13th century. A rebuilding of 1647 is well documented. In its time it has supplied power for grinding corn, malting and fulling, and in the 19th century was used as a paper-mill and a worsted factory. The mill is now a private house, but its machinery remains.

Eric de Maré 1956

3 DEPTFORD BRIDGE MILLS (TQ 374769), GREENWICH, GREATER LONDON

Roller milling in Britain probably dates from 1872, when a German milling engineer, Oscar Oexle, erected a set of roller mills in Glasgow. By 1885 many of the leading British millers had installed full roller plants. The large flour mills on Deptford Creek were operated by J. & H. Robinson Ltd.

Bedford Lemere 1896

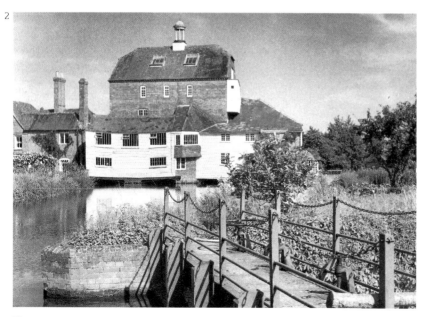

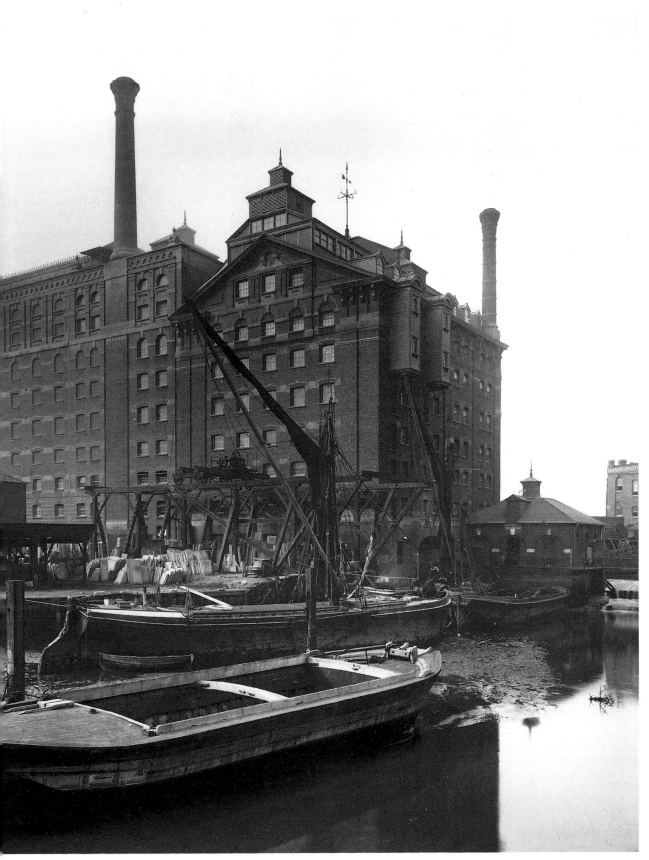

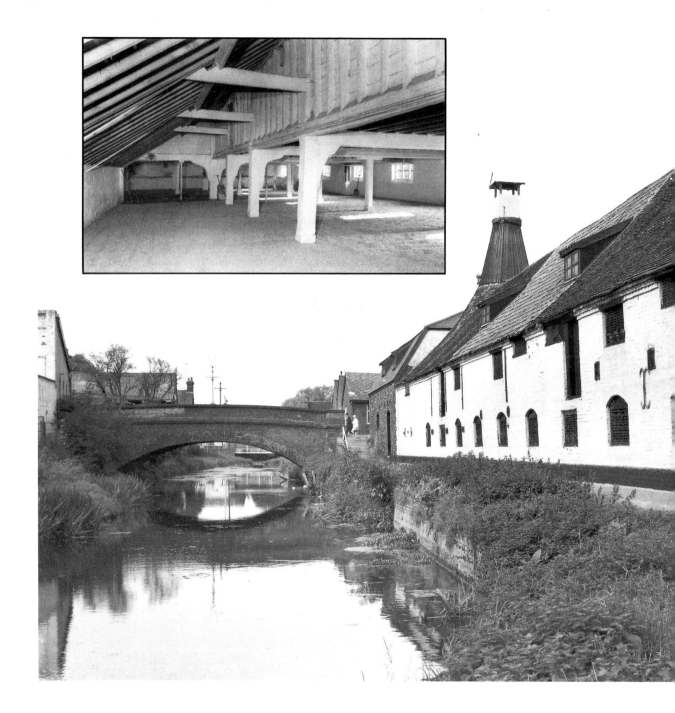

4 MALTINGS (TM 051588), STATION ROAD, STOWMARKET, SUFFOLK

Much of the malt from East Angia, the most important barley-growing area in Britain, was sent
to other parts of the country, especially London. Therefore, maltings were sited to take
advantage of water transport. This example is at the head of the Ipswich & Stowmarket
Navigation, opened in 1793, which was the improved River Gipping. The earliest parts of this
building date from very soon after the opening of the Navigation. These illustrations are from a
series taken when the malthouse was still used for its original purpose, but it has since been
converted into a restaurant.

Hallam Ashley 1971

THE brewing of beer from grain has prehistoric origins and indeed was common when the quality of water may have been dubious. Originally it was conducted entirely on a domestic scale but by the middle of the 16th century some commercial production was controlled by licences. The making of cider from apples, and wine from grapes in monastic colonies, however, may in England at least be a medieval development. Until recently, cider production and sales nationally never achieved a scale sufficient to be of much interest to tax gatherers, although some duty was charged in 1643, in 1763, and again in recent years. Malting, on the other hand, as an essential preliminary to brewing, was increasingly the object of taxation and indeed the technicalities of the gauging of duty greatly influenced the form of the maltings themselves. As the steeping of the malt was controlled in regulation-shaped cisterns at the lowest level of the building, early maltings seldom exceeded three levels - usually two maltings floors and a storage floor in the roof [4]. It is not until the abolition of the malt tax in 1880 that multi-storey maltings appear [5].

5 MALTINGS (TM 122318), BALTIC WHARF, MISTLEY, ESSEX

These very large and imposing maltings were built by Free, Rodwell & Company, 1896. Here Robert Free developed a number of important innovations in both steeping and drying malt. The new types of furnace flues and self-emptying tanks he invented were made of cast iron at the Lawford Ironworks in nearby Manningtree.

Eric de Maré 1956

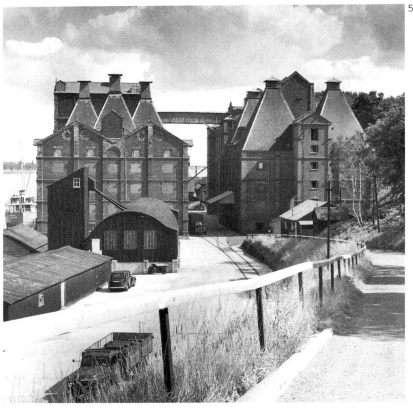

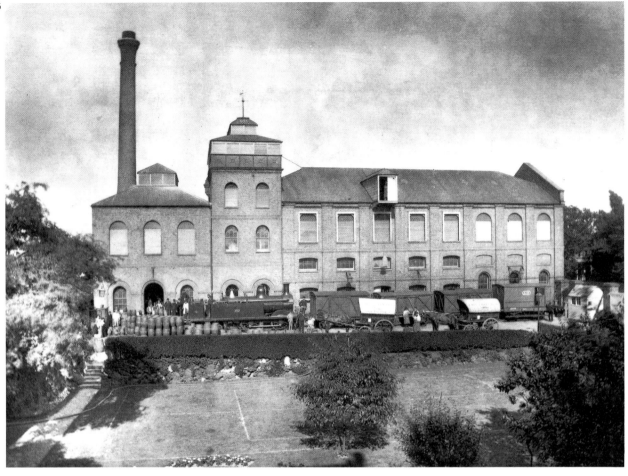

6 CANNON BREWERY (TQ 249779), NORTH END ROAD, HAMMERSMITH & FULHAM, GREATER LONDON

The brewery, originally established in 1831 by Henry Lovibond at Langport in Somerset, was first moved to Vauxhall and subsequently to Chelsea. In 1867 Henry Lovibond built the Cannon Brewery in the grounds of his house, The Hermitage, in North End Road, Fulham. This photograph, taken from a first floor window of The Hermitage and showing its formal garden in the foreground, was used by Henry Lovibond & Son in their advertising.

c.1885

Brewing, partly because of the poor keeping properties of beer before the use of hops, tended until the late-18th century to be of a scale to satisfy immediate local demand alone; it was only in major concentrations of population such as London that a significant brewing industry developed. The use of hops and especially the availability of suitable water allowed the emergence of brewing centres such as Burton on Trent and Alton, Hampshire, in addition to London, but this did not prevent local breweries from flourishing. By the end of the 19th century most towns had one or more breweries and the majority of these were arranged on the tower principle with gravity achieving much of the movement between processes. In larger concerns the liquor was moved by pumps (and latterly by pneumatic means) allowing the buildings to spread horizontally [6].

The 19th century witnessed the emergence of a wide variety of food processing industries to serve unprecedented concentrations of population. Many of the processes which had traditionally been associated with the domestic kitchen or farmhouse were now elevated into industries. Thus cheese factories, creameries, milk condensories and specialist preserve-making firms were established, the last usually in or near ports with ready access to imported sugar and fruits but also at market locations as with Cooper's marmalade in Oxford [7].

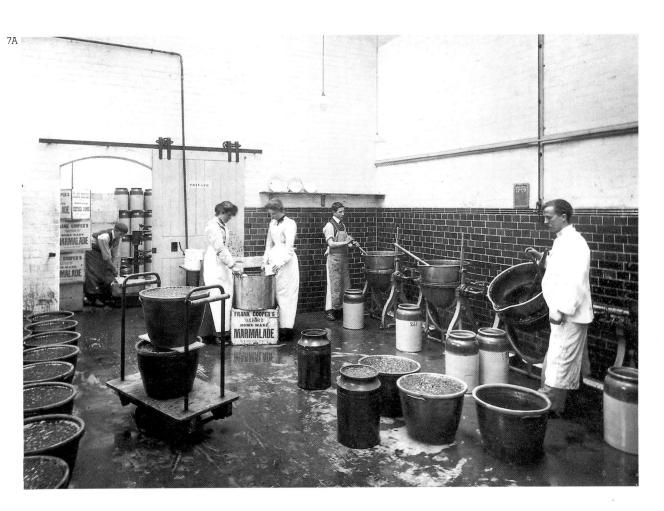

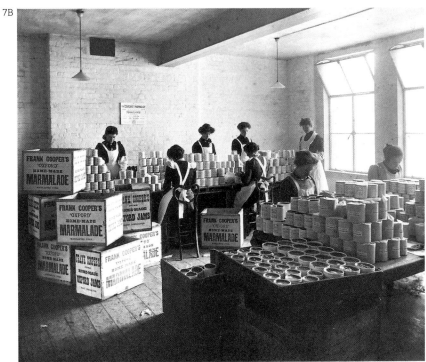

7 COOPER'S MARMALADE FACTORY
(SP 507062), PARK END STREET, OXFORD,
OXFORDSHIRE

Mrs Frank Cooper of Oxford started selling
marmalade in 1874, and by 1900 this was so
successful that a purpose-built works was
erected in Park End Street. Large numbers of
workers were needed to run even small-scale
industries such as this where mechanization
was not introduced until much later in the
20th century. This photograph is one of a
series commissioned from the Oxford
photographer, Henry Taunt (*cf. 38*), to
illustrate the complete process of
manufacturing preserves in the new factory.
The company moved to new premises on the
outskirts of Oxford in 1947 and twenty years
later left for Scotland.

*H.W. Taunt, c.1902; Oxfordshire County
Libraries*

IT was not only food industries that were traditionally in the country. Other industries such as basket making, wood turning, charcoal burning and peat cutting were formerly of some importance. The demand for the products of most of these industries peaked before the units of production achieved significant proportions; as a result there is typically little physical evidence for their existence. Charcoal burning, for example, was formerly of fundamental importance to a wide range of industries such as the smelting and forging of iron, the production of steel by the cementation process, glassmaking and as an ingredient of gunpowder. It is produced by burning wood in a diminished supply of air and throughout the period of its greatest demand it would seem to have been made at a great many small scale sites [8]. At the end of the 17th century, for example, Rockley blast furnace in South Yorkshire was supplied, over a period of six years, with charcoal from no less than 43 different sites up to 12 miles distant. Charcoal burning relied on cropping coppiced wood and was thus an itinerant occupation, with the burners themselves often living in transient encampments of turf huts. These survived in areas such as the Weald well into living memory.

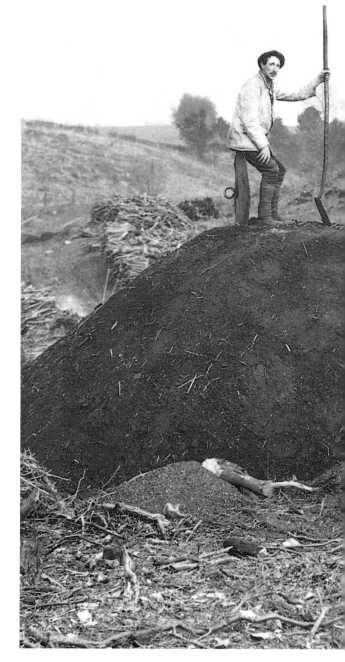

8 TIDENHAM CHASE (ST 5598), TIDENHAM, GLOUCESTERSHIRE

The process of charcoal manufacture was to burn wood very slowly in conditions starved of oxygen in low mounds or clamps. Charcoal for fuel had been produced by this method for centuries by charcoal burners who moved from one part of the woodland to another as their supplies of wood dwindled and regenerated. By the 17th century there were well established systems of coppicing which allowed an area up to fifteen years of growth before its next cutting in rotation. This photograph shows a completed clamp ready for firing.

W.F. Taylor 1928; B.T. Batsford Ltd.

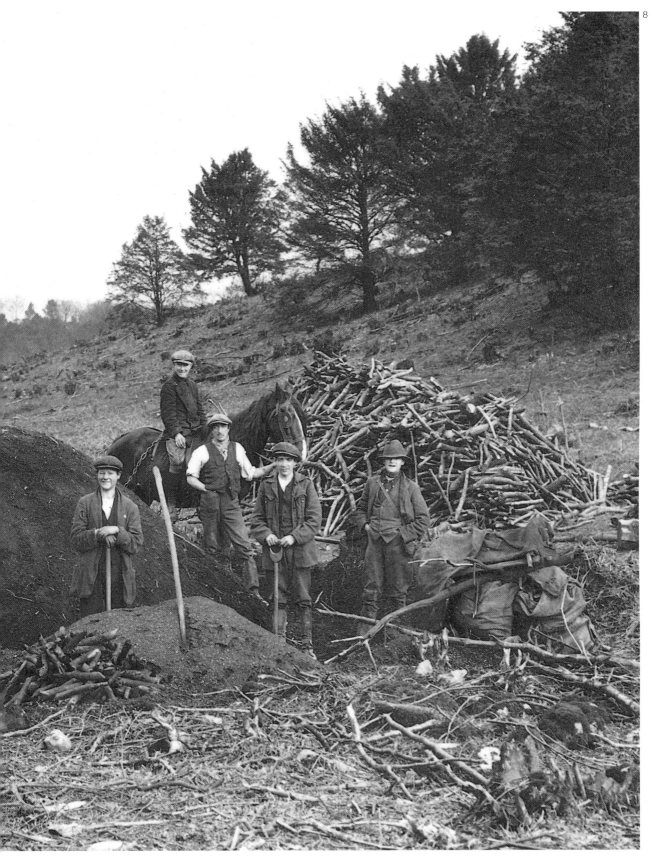

PEAT cutting was an activity which cumulatively over the years reached industrial proportions in its extent and impact on the landscape: the formation of the Norfolk Broads, which are flooded peat diggings, is the outstanding example. As with charcoal burning, however, the methods of production are timeless [9] and probably differed little whether supplying domestic fuel or fuel for hearths for smelting lead ore. The use of peat for horticulture is relatively recent and accounts for most modern cutting, now mechanized, but historically peat has been used as an agricultural fertilizer.

9 SHAPWICK HEATH (ST 4340), SHAPWICK, SOMERSET

Peat-cutting was well-established by the medieval period in the area known as the Somerset Levels. After the peat blocks (mumps) had been cut by hand they were built up into conical stacks, 'ruckles'. Machines have now replaced the hand-cutters and the predominant use of the peat has also changed from fuel to fertilizer.

LMS Collection 1898.

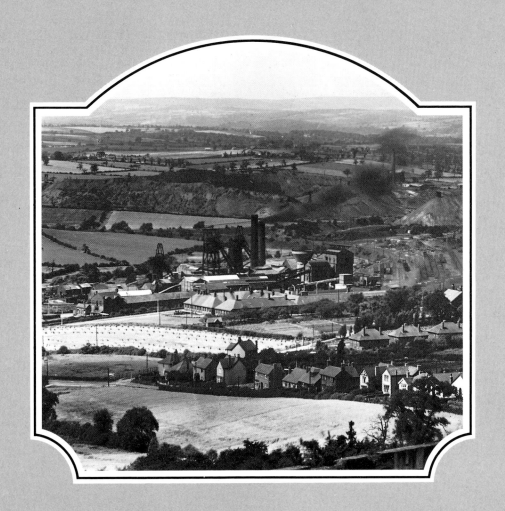

EXTRACTIVE

COLLIERY (SK 461711), OLD BOLSOVER, DERBYSHIRE

F.J. Palmer 1950

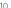

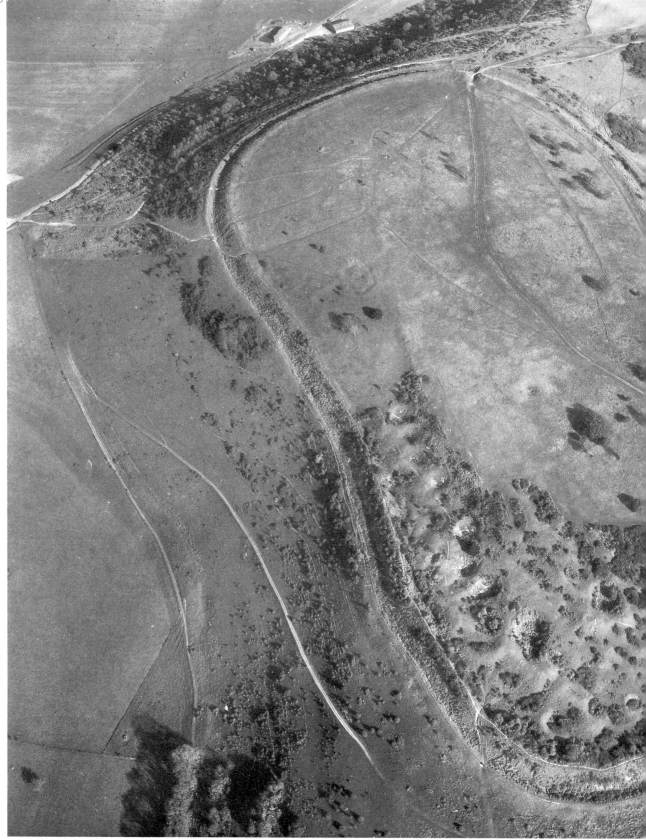

22

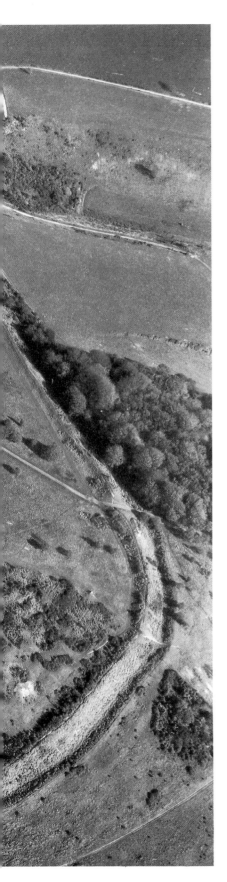

QUARRYING AND MINING OF STONE, SLATE AND CHINA CLAY

THE working of flint and stone for tools and weapons is the earliest industry and the products of carefully selected sites were transported over large distances in the third and fourth millenium BC. During the Neolithic period flint mines developed beyond simple holes in the ground; sites such as Grimes Graves in Norfolk and Cissbury in Sussex have vertical shafts to radiating galleries in the flint bearing levels [10]. From the air these sites present a pock-marked landscape not dissimilar to the bell pits of much later coal and ironstone mining [11]. The flint-mining technology does not seem to have been applied to the mining of other materials and it is not until the Roman period that there is any evidence of systematic quarrying of fine stone such as at Bath and on the Isle of Purbeck.

11

10 FLINT MINES (TQ 137079), CISSBURY, WORTHING, WEST SUSSEX

The earliest mining was for flints, from which tools were made. By the Neolithic period, elaborate mines were being dug to reach the flint-bearing layers in the chalk. This air photograph shows a cluster of more than 200 pits, dating from about 2,900 to 2,500 BC., lying within a later Iron Age hillfort. Some of the shafts go down over 40 feet (12 m.), passing through several seams of flints, each with radiating galleries.

RCHM 1975

11 BELL-PITS (SE 654936), RUDLAND RIGG, BRANSDALE/FARNDALE WEST, NORTH YORKSHIRE

The simplest method of mining was by sinking bell-pits, so called because in section they have the shape of a bell. Where a mineral seam lay close to the surface, a pit was dug and cut away around the bottom in all directions until the sides were in danger of collapse. The pit was then abandoned and a new one started nearby. Bell-pits were usually shallow and very close together. The ground surface of these former workings is characterized by a pock-marked appearance. This air photograph shows 18th-century pits dug for coal which were worked until 1912 in the area of this 1 mile (1.5 km.) long group.

RCHM 1979

THAT such stone was highly prized is indicated by the long distances that it was transported. Such instances were a rarity, however, and most building stone was used locally, being open quarried from outcrops by methods that changed little until recent times. In the last two centuries some of the stone of the Jurassic limestone belt, and particularly Bath stone, has been mined as distinct from quarried and some of these abandoned mines display the marks of traditional methods of stone quarrying [12]. Elsewhere natural weathering in abandoned quarries and modern methods of extraction in quarries still in use have generally obliterated most traces of earlier working.

The increased amount of building in the 16th and 17th centuries not only created a demand for stone but also for slate as a roofing material. While some of this demand was met by quarrying poor quality local resources, records show that slate from high-quality deposits such as at Delabole in Cornwall and Kirby-in-Furness and Coniston in Cumbria was widely distributed from at least the 17th century onwards. These workings created extractive landscapes equalled in England only by the recent stone quarries of the Mendips, Derbyshire and the Isle of Portland and the area of china clay working to the north of St Austell in Cornwall [13]. This latter industry was the result of the discovery in the 18th century of the benefits of the use of kaolin in the manufacture of fine porcelain; now much of the output goes to other industries ranging from papermaking to toothpaste and cosmetics.

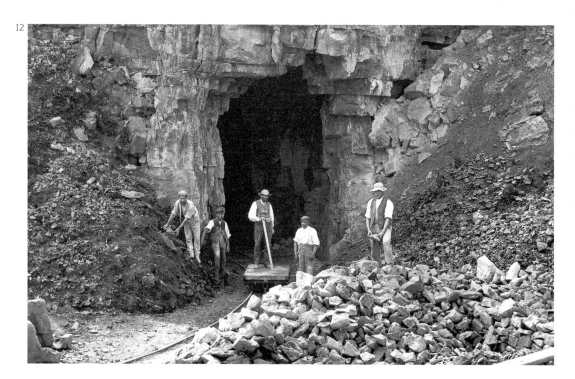

12

12 WESTINGTON MINE (SP 140366), CHIPPING CAMPDEN, GLOUCESTERSHIRE

The Cotswolds are well known as a source of the building stone, oolitic limestone. This can vary in colour from yellow to dark brown; the variations are due to an iron mineral called limonite. Oolitic limestone is composed of very small fossils, giving a fine grain, which is both easy to work and leaves the stone less prone to weathering. For these reasons Cotswold stone has been mined and quarried for building for centuries.

H.W. Taunt 1895; Oxfordshire County Libraries

13 WHITE MOOR (SW 977567), ST STEPHEN-IN-BRANNEL, CORNWALL

The mineral which provided the key to the making of hard porcelain was kaolin or china clay, the properties of which were discovered in the mid-18th century. China clay is produced by the decomposition of the felspar that occurs in Cornish granite. Most of the china clay found in Britain has come from the area north of St Austell in Cornwall and its exploitation over two centuries has led to the characteristic 'lunar' landscape seen here.

RCHM 1977

13

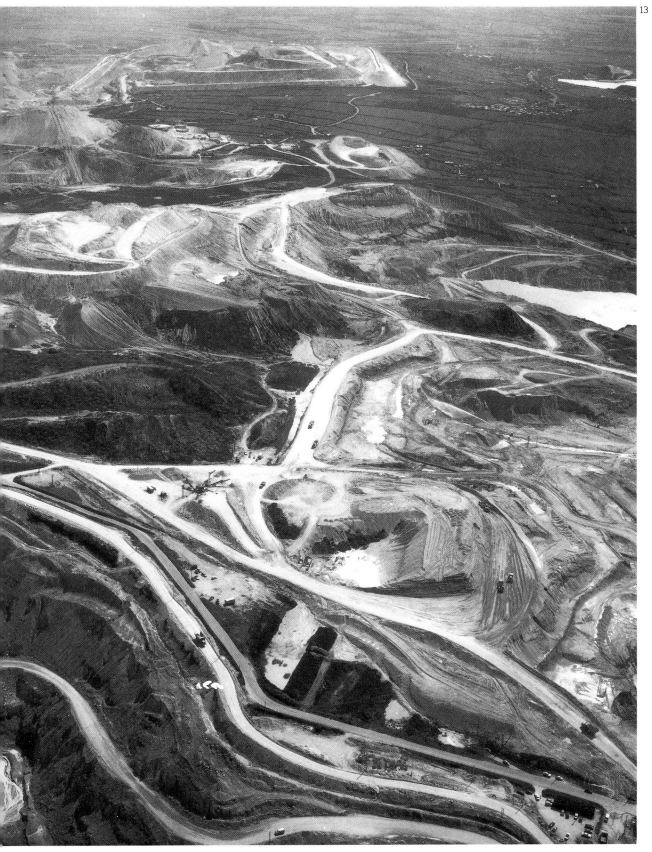

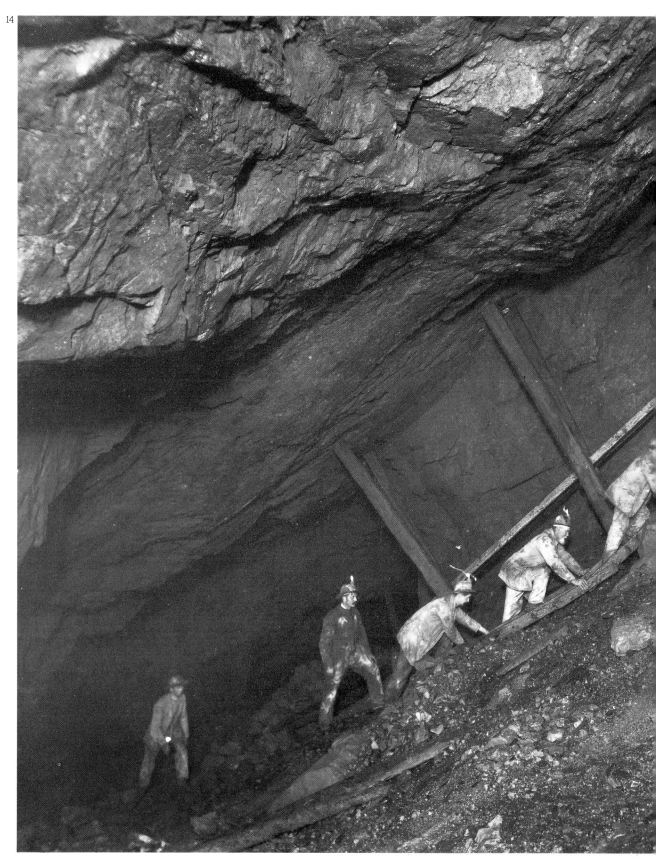

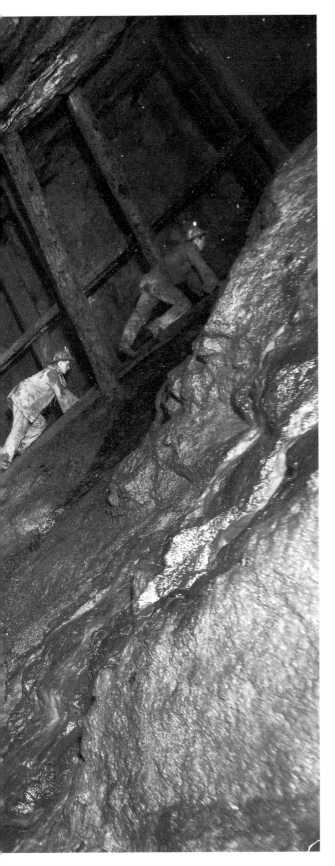

MINING OF METAL ORES

THE history of the mining of both ferrous and non-ferrous metal ores in England is as long as documented history itself. While metal working was known for two millennia before the Claudian invasion, the Romans stimulated and organized the production of metal ores to an unprecedented degree. Some seventy pigs of lead bearing imperial stamps, for example, have been discovered in widely varying locations; many were presumably lost while being transported to ports for export. At Charterhouse on Mendip, in the heart of the mining area, extensive remains of a Roman settlement indicate how the search for ores, then as later, took people to inhospitable uplands.

In areas such as Cornwall, mining of tin, lead and copper was facilitated by the introduction of shaft mining in Tudor times and production steadily increased until a peak in the 19th century. Although by then the use of steam engines allowed much deeper mines than hitherto, many of the underground methods of working had been little changed for centuries and survived long enough to be captured by J.C. Burrow in a remarkable series of photographs [14].

Associated with most metal mining was an initial refining of the ore. This could be achieved by mechanical or chemical means or by a combination of both. The former might involve crushing and washing, while the latter was aided by burning off impurities. Both processes called for specialized structures such as the dressing floors of the non-ferrous mining areas [15] and the calcining kilns of the ironstone industry [16].

14 SOUTH CONDURROW MINE (SW 661389), CAMBORNE-REDRUTH, CORNWALL

Copper was the most profitable mineral mined in Cornwall for around 150 years. In 1700 the output was only about 2,000 tons, but this rose to 140,000 tons by about 1860, after which there was a steady decline due to competition from imports. The South Condurrow copper mine was in operation from 1848, although there is some evidence of earlier workings. In 1897 part was taken over (later to become the separate King Edward VII Mine) and it ceased production in 1920. The miners in this photograph are climbing a ladderway and incline skiproad at the 450 feet (135 m.) level; note that illumination is still by naked lights, a method unchanged for centuries.

J.C. Burrow 1896; Royal Institution of Cornwall

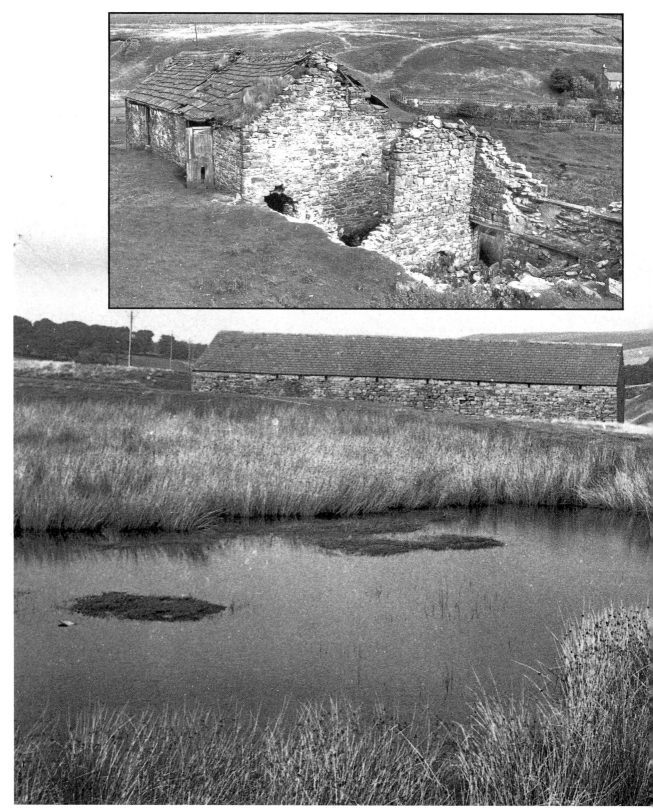

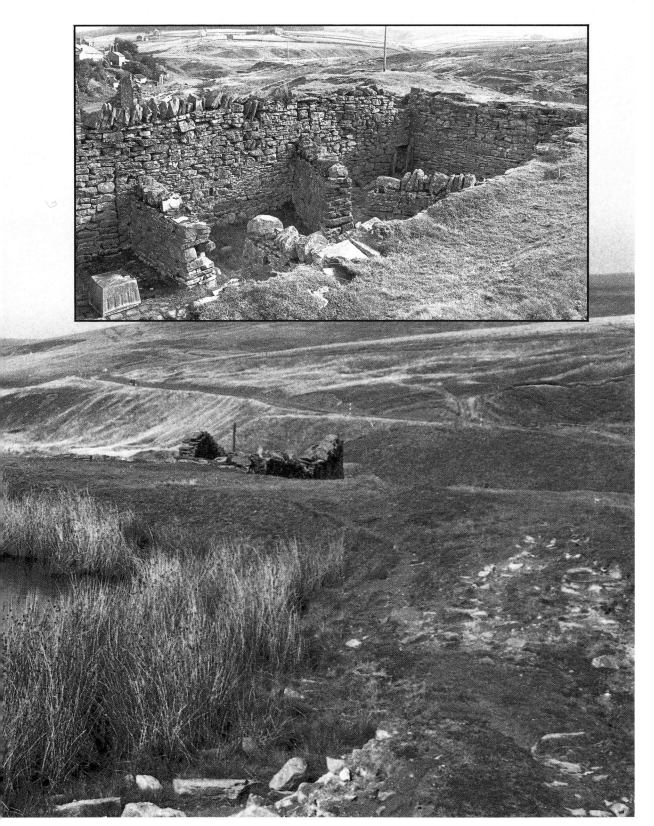

Previous page

15 LEAD SMELTING MILL (NY 851464),
ALLENDALE, NORTHUMBERLAND

In Britain, lead is never found in pure form,
but it is generally compounded with sulphur
to form lead sulphide, called galena. The
process of extracting pure lead entails
roasting the crushed ore and collecting the
molten metal at the bottom of a furnace. The
area around Allenheads in Allendale was one
of the most prosperous 19th-century lead
mining sites in the north of England. This lead
smelt mill, near the village of Dirtpot, was
built by the Beaumont family before 1725 and
closed in 1870.

Hallam Ashley 1973

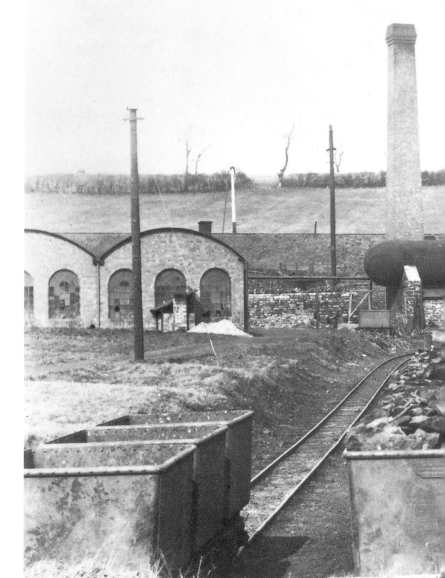

16 IRONSTONE QUARRY (SP 368339),
HOOK NORTON, OXFORDSHIRE

Jurassic iron ores worked by opencast
methods occur in a broad band stretching
across the country from the Cleveland Hills to
the Cotswolds. With a relatively low iron
content, the ores were usually calcined –
reduced by burning – close to the quarries.
The calcining kiln in this photograph
belonged to the South Wales and Cannock
Chase Coal and Coke Company.

H.W. Taunt 1906;
Oxfordshire County Libraries

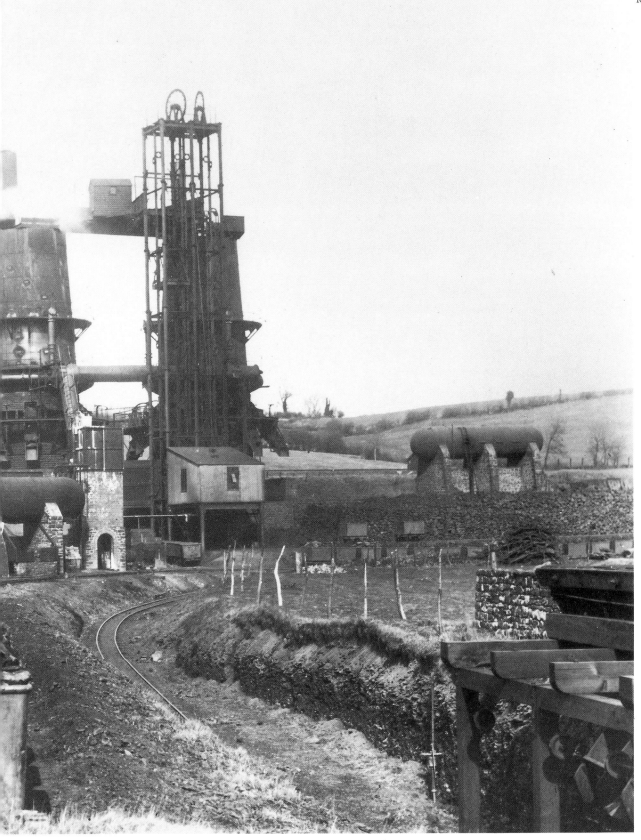

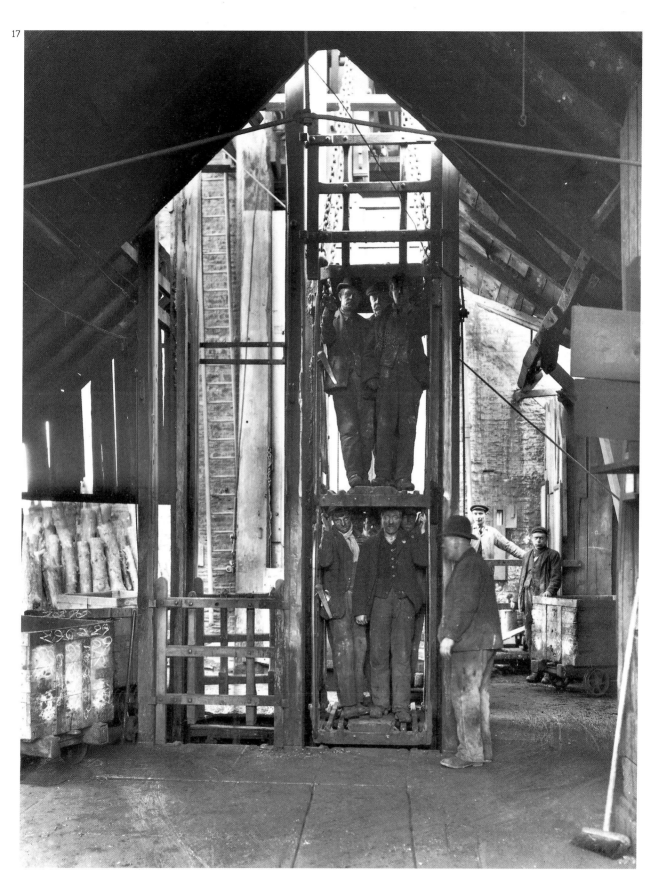

COAL MINING

OF all the main extractive industries, coal was the last to develop in a significant way but the first to achieve an annual production measured in millions of tons. Although there is archaeological evidence for the use of coal in the Roman period from sites as distant as Hadrian's Wall and Bath, production remained of only local significance until the 16th century when the price of timber rose much more than that of other commodities. The concern of Tudor monarchs to conserve strategic supplies of timber for their navy forced other major users to look elsewhere for fuel and thus coal was increasingly used for glassmaking, malting and other processes. The London market stimulated a significant trade in coal from the River Tyne amounting c.1700 to an estimated $\frac{1}{2}$ million tons out of an annual national production of perhaps some $2\frac{1}{2}$ million tons.

Pithead arrangements remained rudimentary until the introduction of steam pumping in the 18th century. The custom of backfilling pits with spoil has left very little surface evidence of pre-19th century mining apart from a few isolated coalfields such as, outstandingly, Clee Hill, Shropshire, and a small number of structures and especially engine houses as at Saltom, near Whitehaven, and Elsecar, near Barnsley. Throughout the 19th century the industry expanded at a prodigious rate – from an estimated annual production of 10 million tons in 1800 to a peak production of 287 million tons in 1913. Despite rapid technological advances in the middle of the century in pumping, winding and grading of coal, working conditions remained somewhat harsh. The situation depicted by Burrow at the turn of the century was by no means unusual and indeed survived until after World War Two at smaller mines in areas such as the Bristol coalfield [17]. The remains of 19th-century mining are much less common than might be expected. Coal mines were frequently worked on lease from landowners and their often insubstantial buildings were cleared when mining ceased. There are, however, some striking exceptions, especially where landowner involvement resulted in more heavily capitalized mines. On the southern hillside at Whitehaven, for example, an elaborate series of terraced mine structures were disguised to present an acceptable appearance when viewed from Lowther Castle. The surviving structures include a candlestick-shaped chimney of 1840, a Guibal ventilation fan-casing built to resemble a small church, and castellated lodges, all associated with the Wellington Pit and, to the east of the town, a lone castellated chimney graced the Davy Pit. These extravagances were echoed further up the Cumbrian coast at Workington where, in 1843, Henry Curwen adorned his Jane Pit with a series of crenellated structures [18].

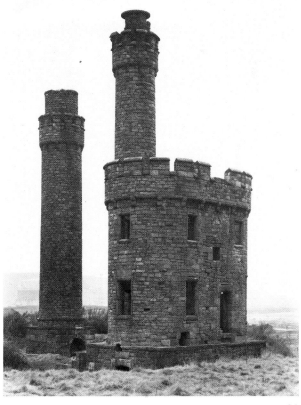

18

17 FROG LANE COLLIERY (ST 687815), WESTERLEIGH, AVON

The Bristol coalfield was one of the earliest in Britain; coal working is mentioned as early as 1223 and the names of actual miners are recorded in the Patent Rolls of 1296-1300. To meet the growing demand for coal in the 19th century, new large pits like Frog Lane were sunk. Two shafts were sunk by the Coalpit Heath Collieries early in the 1850s; the winding shaft was 660 feet (198 m.) deep and the pumping shaft was 690 feet (207 m.) deep. The colliery closed in 1949.

J.C. Burrow c.1905; Royal Institution of Cornwall

18 JANE PIT ENGINE HOUSE (NX 995277), WORKINGTON, CUMBRIA

The West Cumbrian coalfield is a comparatively small one, but it produced a colliery architecture out of all proportion to its size, resulting from the domination in the mid-19th century of a few large landowning families. The second Earl of Lonsdale, for instance, employed Sydney Smirke, architect of the British Museum Reading Room, to design works at Whitehaven. At Workington the ruling family was the Curwens and about 1843 Henry Curwen sank the Jane Pit with its splendid castellated chimneys and pumping house.

RCHM 1968

19

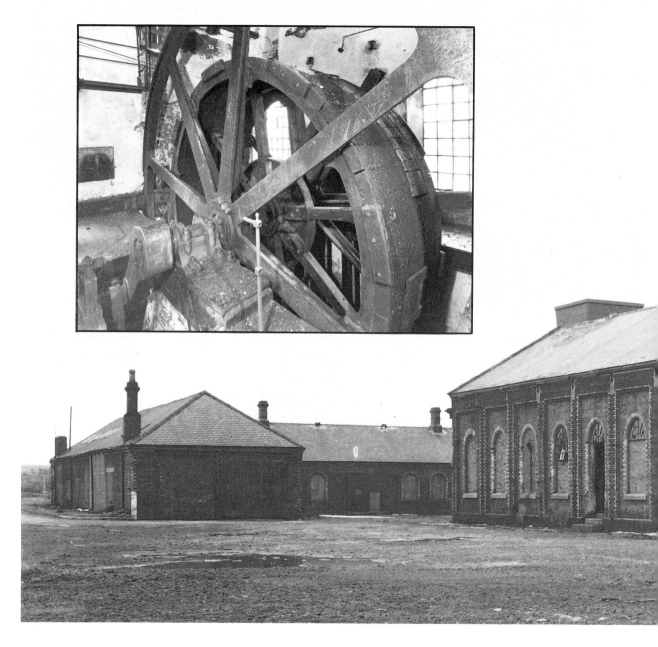

IN recent years increasing concern for public liability and for
environmental amenity has resulted in the clearance of many
historic pitheads. For example, Elemore Colliery near Durham, which
contained the last *in situ* example of a direct acting vertical steam
engine, was demolished in 1979 [19] and now only the re-erected
example at Beamish Open Air Museum survives to illustrate a breed of
engines once typical of the North East coalfield. The derelict land
reclamation programme in the last few years has transformed the
landscape in areas such as County Durham and West Yorkshire [20]
to such an extent that in some instances only the distinctive colliery
villages indicate areas of former mining.

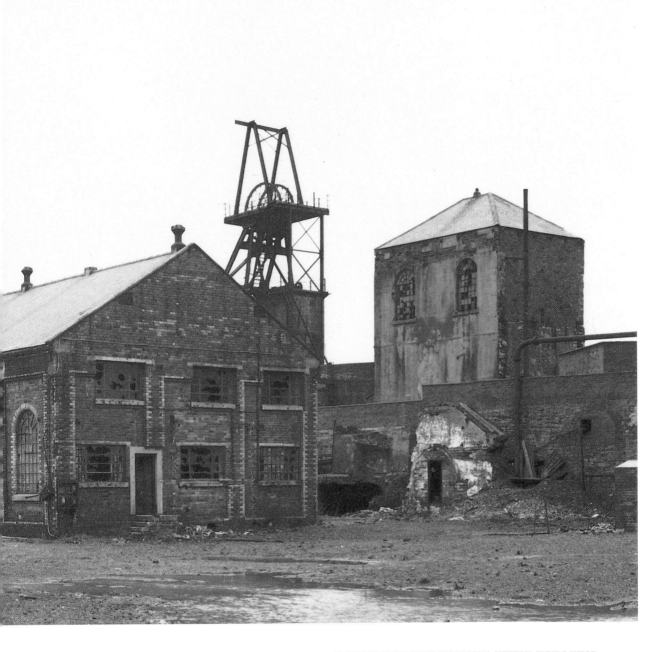

19 ELEMORE COLLIERY (NZ 356457), HETTON, TYNE & WEAR

The earliest use of the steam engine in mining was for drainage and it was not until 1784 that the first steam winder was introduced. A notable regional variation from the standard horizontal winding engine occurred in the North East, where vertical winding engines were common on the Northumberland and Durham coalfield. The direct-acting vertical engine with crankshaft mounted above the cylinder was patented by Phineas Crowther of Newcastle-upon-Tyne in 1800. The *Isabella* engine at Elemore colliery, installed about 1825, was the last example *in situ*, surviving until 1979.

RCHM 1979

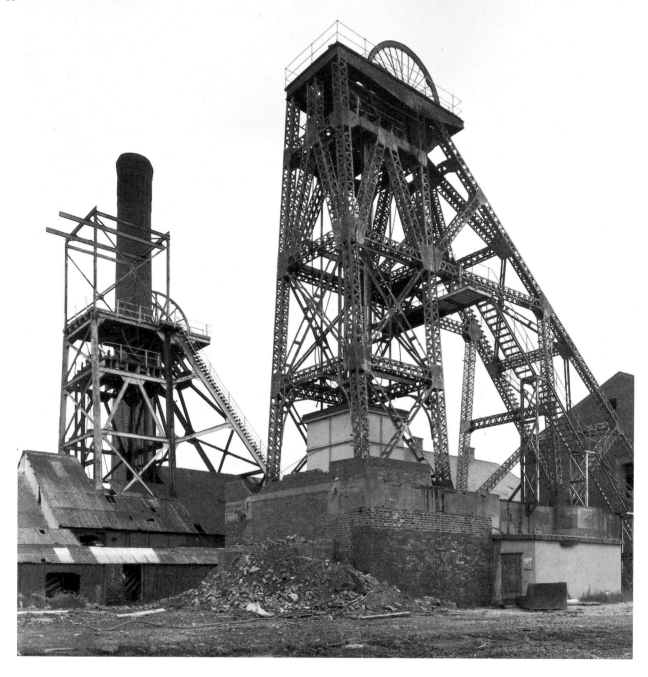

20 WALTON COLLIERY (SE 360183), WALTON, WEST YORKSHIRE

Walton colliery, on the southern outskirts of Wakefield, was a branch of the New Sharlton Colliery Company. The first shaft was sunk in 1890 and the colliery reached the peak of its production in the early 20th century. It is unusual in having remained little altered since then, and following its closure there have been proposals to open the colliery to the public as a museum of mining. The two headstocks in the photograph are (*right*) No.1 Shaft, with its typical late 19th-century lattice ironwork construction, and (*left*) No.2 Shaft of 1923, which was the main shaft for bringing up coal.

RCHM 1981

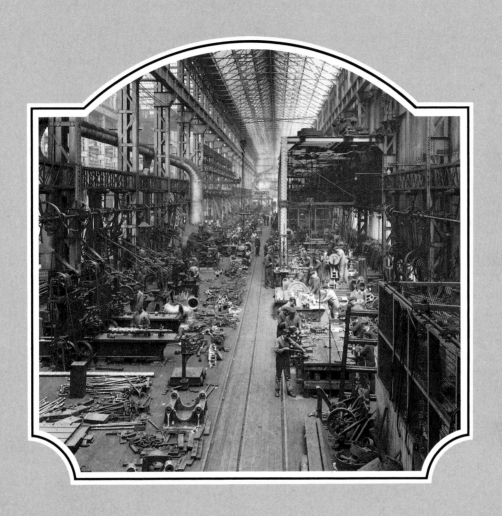

METALS, CERAMICS
AND CHEMICALS

CAMMELL, LAIRD & COMPANY SHIPYARD (SJ 330883), BIRKENHEAD, MERSEYSIDE

Bedford Lemere 1913

THE MAKING AND WORKING OF METALS

METAL ores, in common with most of the raw materials for industry, have to undergo some conversion before they can be used for other industrial purposes. The smelting of metal ores has a technology extending back into prehistory and, indeed, it is the advances occasioned by the discovery of smelting of different metals that give us those traditional divisions of prehistory, the Bronze and Iron Ages. The technologies involved are quite different. In the case of non-ferrous metals the melting point can be achieved by normal fires whereas, until the introduction of the blast furnace, iron with its melting point of 1540°C, had to be reduced in a spongy state and many of the impurities expunged by mechanical means.

The charcoal-fired blast furnace first made its appearance in England in 1496, a century after its development on the continent, but its product (cast iron) required further conversion by heat and mechanical processing before it could be used for traditional iron products. In 1709 the coke smelting of iron was developed by Abraham Darby at Coalbrookdale [21] and by the end of the century coke had almost entirely replaced charcoal. In the succeeding century the production of cast iron was greatly increased by the development of hot blast furnaces [22-3]. Its conversion into wrought iron was revolutionized by the puddling process patented by Henry Cort in 1784 and improved by Joseph Hall c.1830.

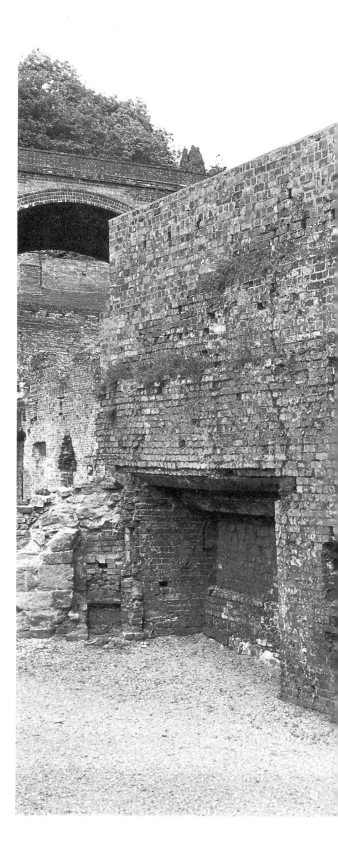

21 BLAST FURNACE (SJ 667047), COALBROOKDALE, DAWLEY, SHROPSHIRE

The first decade of the 18th century saw a major breakthrough in the smelting of iron by the use of coke rather than charcoal. The coke smelting process was developed by Abraham Darby at Coalbrookdale in 1709. The blast furnace where Darby perfected these techniques survives and is preserved by the Ironbridge Gorge Museum Trust. It was originaly built as a charcoal-fired furnace in 1638, adapted in 1709 and subsequently enlarged for casting the members of the famous Iron Bridge, completed in 1779. The furnace, which had been buried under a spoil heap, was excavated and consolidated in 1956. The additional brickwork shows up clearly in the photograph.

G.B. Mason 1963

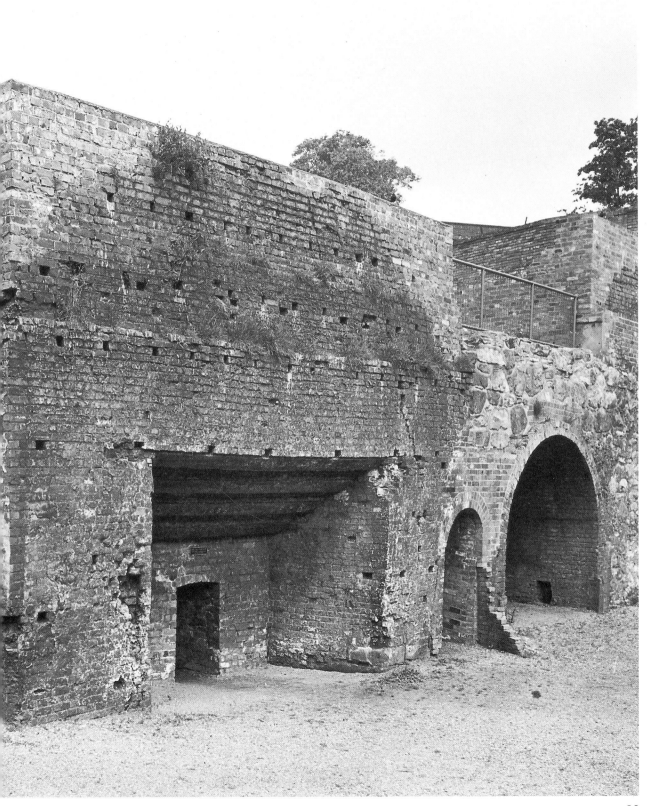

22 GOLDENDALE IRONWORKS (SJ 850516), TUNSTALL, STOKE-ON-TRENT, STAFFORDSHIRE

Goldendale was once a very busy industrial area of Stoke-on-Trent, which included the large Ravensdale forges, collieries and brick and tile works. The Goldendale blast furnaces were opened in 1840 and closed down in 1969. This photograph was taken as part of a comprehensive survey undertaken by Staffordshire County Council to record historic buildings and sites. Particular attention was paid to industrial remains and works still in operation were photographed in detail.

Staffordshire County Council 1968

23 CONSETT (NZ 0950), DURHAM

The iron industry was an early development in the North East owing to the convenient proximity of coal and iron ore. When the local ores became exhausted, richer ones were imported to keep the furnaces in operation. The industry has, however, undergone many fluctuations during the 19th and 20th centuries. The town of Consett was very much the creation of the Consett Iron Company of 1841. By 1881 the company employed 6,000 workers and owned more than 2,000 houses. From their opening to their closure in 1980, the ironworks dominated the town, both physically and economically. Regrettably, neither the name of the photographer nor the date of this photograph is known.

22

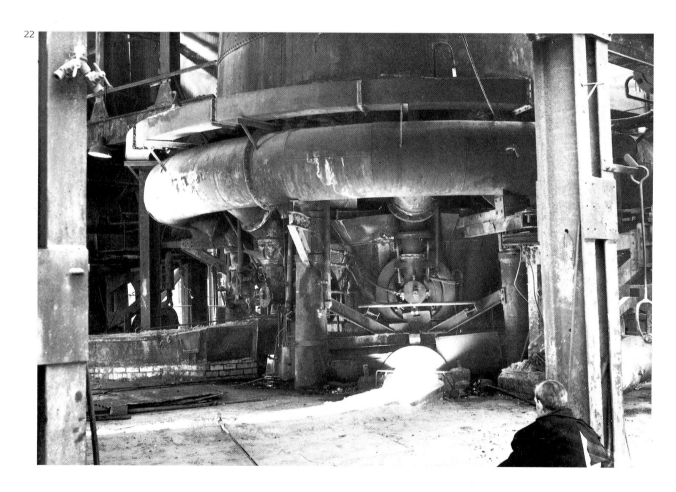

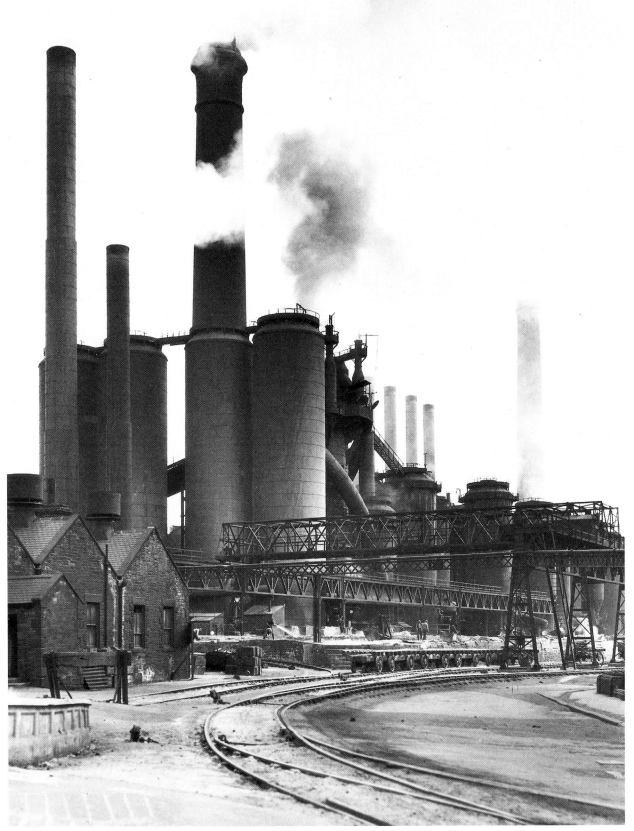

THE availability of cheap wrought iron and, somewhat later, cheap mild steel after the invention of the Bessemer converter in 1856 allowed a much wider range of metal working industries to develop such as the construction of iron ships [24]. The development of metal-working technology proceeded at a parallel pace. The introduction of machine tools allowed machinery with fine tolerances to be mass-produced. The engineering industry, which had been founded on the construction of steam engines in the 18th century, expanded greatly in the 19th century to encompass textile machinery, locomotive building and, by the end of the century, car assembly [25].

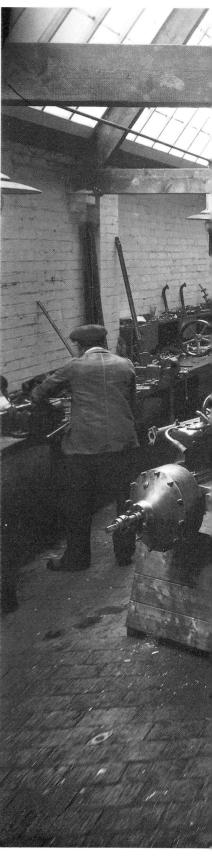

24

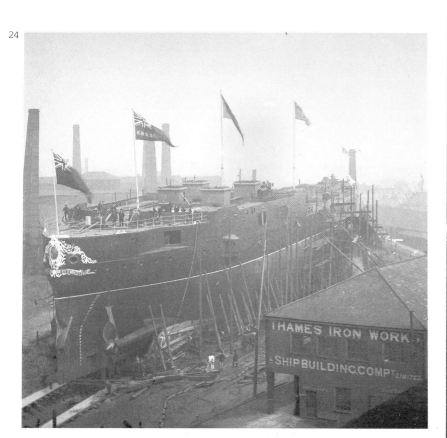

24 THAMES IRONWORKS (TQ 395810), BOW CREEK, NEWHAM, GREATER LONDON

Shipbuilding began on this site in 1846, when C.J. Mare & Company founded the firm which was to become the Thames Ironworks & Shipbuilding Company in 1857. During the late 19th and early 20th centuries the works specialised in building warships and liners. This photograph is one of a series taken on 9 May, 1887, during the launch of *HMS Sans Pareil*, a battleship of 11,000 tons costing £845,000 and broken up in 1907. The Thames Ironworks closed in 1912 after the completion of *HMS Thunderer*.

H.W. Taunt 1887; Oxfordshire County Libraries

25 STANDARD WORKS (SP 337778), MUCH PARK STREET, COVENTRY, WEST MIDLANDS

The internal combustion engine was developed in the second half of the 19th century using first gas and then oil. Gottlieb Daimler in Germany developed the first successful high-speed engine running on light petroleum spirit and patented his design in 1885. R.W. Maudslay, inspired by American example, decided in 1903 to start a motor-manufacturing firm. He produced a small number of low-priced models, using interchangeable parts – hence the name *Standard*. The photograph shows engines and other parts being assembled before the introduction from America of mass production methods.

Larkin Brothers 1907

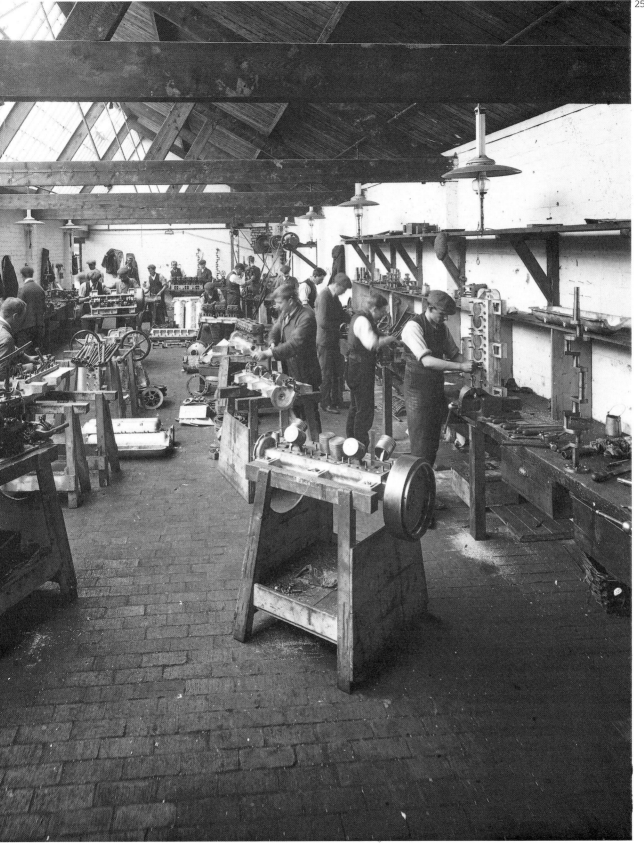

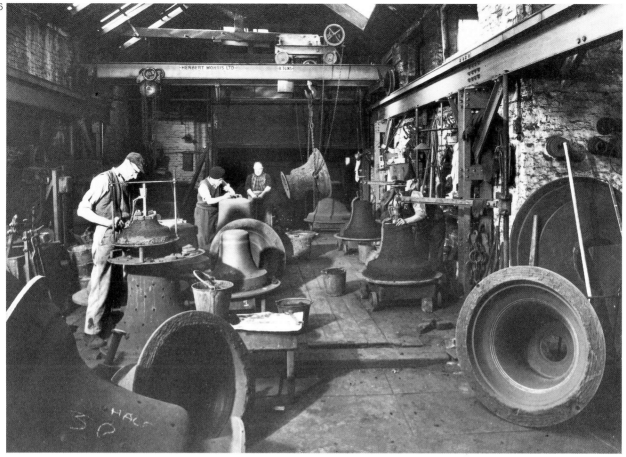

26 WHITECHAPEL BELL FOUNDRY
(TQ 339815), WHITECHAPEL ROAD,
TOWER HAMLETS, GREATER LONDON

The famous church bell foundry remains in
18th century premises and continues to use
traditional techniques with most of its
production by hand. Originally established in
1420 in Houndsditch, the foundry moved to
Whitechapel in 1583. Soon afterwards bells
were cast here for Westminster Abbey.
Formerly other types of brass foundry-work
were also cast there, including, it is claimed,
cannons used against the Armada. In 1738
the foundry moved to its present site in
Whitechapel Road.

Campbell's Press Studio 1956

In some industries, however, traditional methods survived and the
casting of bell metal at foundries such as Whitechapel [26] had altered
little in centuries.

CERAMIC INDUSTRIES

THE technologies of most of the branches of the ceramic industry
(which is taken here to include brick and tile making) are similar:
various combinations of minerals are fused together by heat to form
substances with quite different properties.

The Romans introduced brick and tile making and some of their
products, such as the fragments of the arched roof of the Roman baths
in Bath, testify to the quality and technical expertise of their work; it
would seem, however, that the industry did not survive the 5th century
and that the technology had to be re-introduced from Europe in the
early medieval period. Records show that by the 14th century kilns as
well as clamps were in use and these two methods were to co-exist
until the development of the continuous kiln c.1860 virtually wiped
out other methods of firing. For special quality or shaped bricks where
only small quantities were required, simpler methods of firing survived,
however, and there is still some clamp firing of bricks, as on Hayling
Island [27], and intermittent kiln firing as at Aldeburgh in Suffolk.

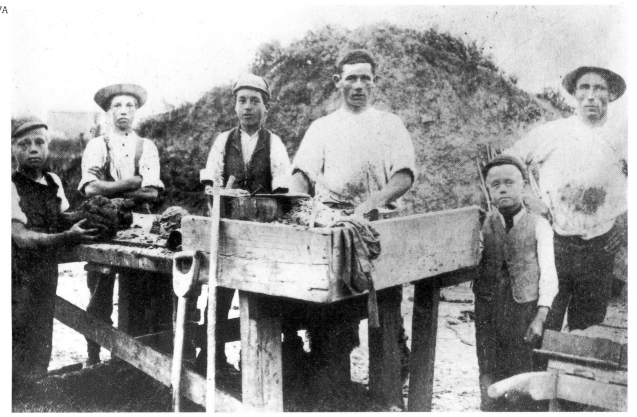

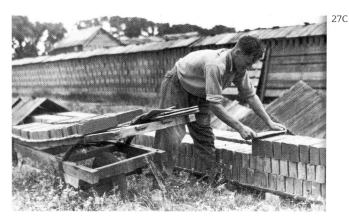

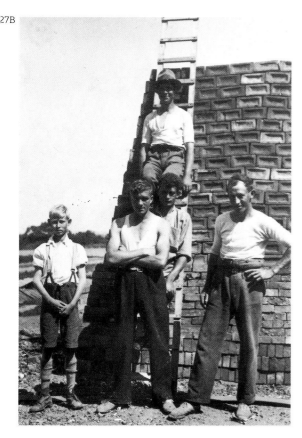

27 PYCROFT'S BRICKWORKS (SU 717034 & 728024), NORTH HAYLING, HAVANT, HAMPSHIRE

This brickworks has been in operation since the early 19th century in the ownership of the same family, and bricks are still being made by hand using the clamp method. The first photograph (*top*), taken in 1887, shows hand moulding and the 'green' unfired bricks ready on the barrow. In the second photograph (*left*), taken in 1935, Harold Pycroft (standing at the right) and his workmen are in front of a newly-built clamp; the bricks on the outside are already burnt and form the casing. The third photograph (*above*), taken in 1948, shows Noel Pycroft, who now runs the firm, stacking green bricks into hacks.

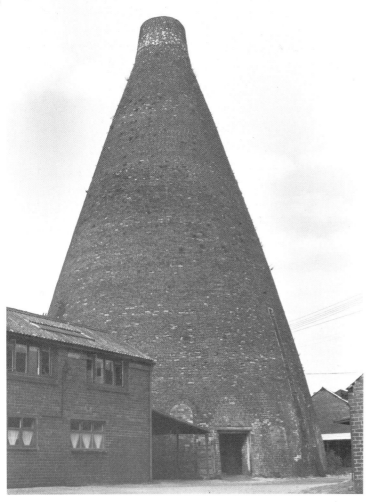

28 RED HOUSE WORKS (SO 894865),
HIGH STREET, WORDSLEY, DUDLEY,
WEST MIDLANDS

A new type of coal-fired furnace with a
characteristic tall cone was developed for
glass works in England in the middle of the
18th century. The cone at the Red House
Works of Stuart & Sons, crystal glass
manufacturers, was built some time after
1780, possibly by the glass-maker Richard
Bradley, who bought the site in 1788. This
brick cone, some 87 feet (26 m.) high, with its
twelve-pot furnace was in use until 1939.

Staffordshire County Council 1961

THE glass industry seems to show a similar history: a period of
non-production after the Roman period and a re-introduction in the
early medieval period. However, the archaeological evidence would
suggest that either the English did not readily adopt the new
technology or that native production was of a less durable glass using
woodland derived alkali. Certainly most of the artefacts of this period
are imported or the product of foreign workers. In an attempt to
improve the quality of English glass, Jean Carré, a glassmaker from
Lorraine, was granted a licence for glassmaking and there is a gradual
spread of techniques from the Weald to Somerset, the West Midlands
and the North East. In the 17th century the native industry seems to
have progressed so much as to be innovatory; reverberatory furnaces
used in conjunction with a tall cone may indeed be an English
development. Glass cones, which could be up to 90 ft. (27 m.) high,
were once a very prominent feature in the landscapes of Bristol,
St Helens, Stourbridge, South Yorkshire and Tyneside, and isolated
examples in various states of completeness survive in all these
areas [28].

The manufacture of pottery in England began in the fourth
millenium BC or even earlier and attained an industrialized peak in

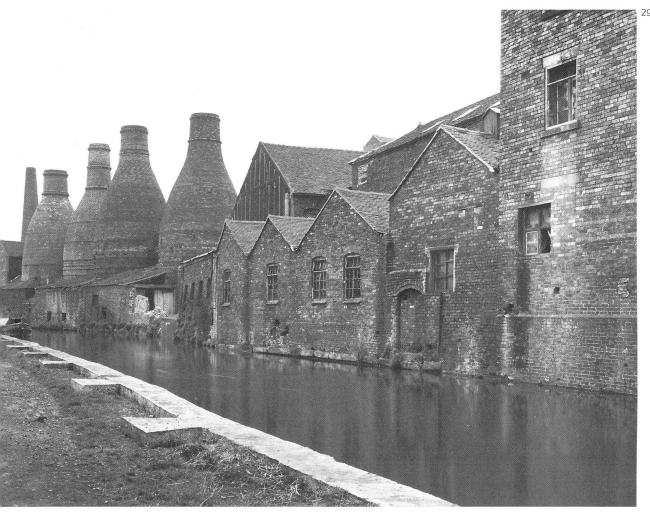
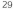

the Roman period. As with other industrial technologies, mass production ceased for a time but by the end of the 17th century pottery manufacture had evolved from a ubiquitous local process to an industry concentrated in favoured locations. Availability of fuel as well as suitable clays seem to account for the initial development of the Staffordshire pottery industry, but technical inventiveness was also important. A sophisticated glazed ware whitened with ground silicon, for example, was produced long before the discovery of the vital role of china clay in the manufacture of true porcelain changed the character of much of the industry in the late-18th century. Despite being so distant from the sources of china clay in the south west, the Potteries area of Staffordshire increased its dominant position in the English china industry by the astute management of entrepreneurs such as Josiah Wedgwood who not only introduced production line processes, but also successfully promoted canals to convey his raw materials and products. By the earlier 20th century, the distinctive Potteries landscape with hundreds of bottle-shaped ovens belching forth smoke had been created, but it has disappeared even more quickly than its development. Only a few dozen bottle-ovens survive, none are in use [29].

29 UNICORN WORKS (SJ 509498), DAVENPORT STREET, LONGPORT, STOKE-ON-TRENT, STAFFORDSHIRE

The area around Stoke-on-Trent was so closely associated with one industry that it became known in the mid-18th century as The Potteries. At that time the industry was developing dramatically with the establishment by the Wedgwoods of large planned factories. Josiah Wedgwood was the chief promoter of the Trent & Mersey Canal, opened in 1777, which enabled the potters to bring in raw materials and to transport their finished products. In this photograph the Unicorn Works, where earthenware was manufactured, is seen backing on to the Trent & Mersey Canal. Bottle-kilns such as these once covered the area, but now most except those few preserved as museum pieces have been demolished.

Herbert Felton 1960

THE CHEMICAL INDUSTRY

THE chemical industry has a long antiquity but has only recently become of major economic significance. Chemicals such as salt (evidenced at Iron Age hillforts), alkali (for soap), and lime have been produced since at least Roman times while gunpowder has been produced from imported chemicals since the late 13th century. Chemical mordants derived from alum and copperas have been used in the dyeing industry from the 17th century, while oil of vitriol (sulphuric acid) was first produced in significant quantities at Twickenham in 1736. Salt and sulphuric acid are the base chemicals for many other chemical processes and the availability of both in quantity allowed the alkali industry to develop in Merseyside and Tyneside.

Originally salt was produced by the evaporation of sea water, and remains of salt pans – where sea water was concentrated prior to being boiled – are to be found at Allonby on the Cumbrian coast where there was a plentiful supply of coal for secondary evaporation. In the kinder climate of the south coast atmospheric evaporation alone was sufficient and there was a ready market, supplying the Navy with preserving salt, and thus extensive salterns were constructed around Lymington and on the Isle of Wight. In 1800 Lymington's trade amounted to 150,000 bushels and was second only to that of Liverpool. The latter's salt however was derived from the evaporation of brine from the Cheshire salt deposits. The traditional open-pan boiling of salt can still be seen at the Lion Salt Works at Marston near Northwich.

Lime burning was commonly practised where geological conditions permitted but, until the late 18th century, was generally on a small scale using insubstantial kilns which have left scant remains. Lime was used for agricultural fertilizer, for tanning, for mortar and for limewash for walls; increasing demand led to the construction of much larger kilns in locations where limestone and fuel could be brought together close to the point of use. The burnt lime was not safe to transport by open water and consequently many kilns were built along the coasts in areas of acid soils where both coal and limestone had to be imported. Safer carriage by canal and, later, railways permitted the construction of large inland kilns such as those of Samuel Oldknow at Marple [30].

In the 19th century arsenic, which had hitherto been present as an unwanted by product of lead

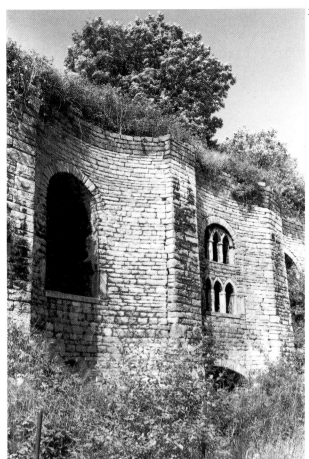

smelting, was produced in some quantity for a variety of uses. Photographs record the rudimentary precautions taken by workers in this fairly lethal industry [31].

Some distillation of oil from English sources occurred in the second half of the 19th century, notably from oil shales but some also from wells. The process did not develop to the scale achieved in the oil shale areas in Scotland, however, and the industry quickly became based on imported oil. Petroleum from the United States, for example, was landed at Herculaneum Dock in Liverpool from the mid-1860s and an oil tank depot was opened to the south of the dock by 1891. This depot could handle bulk supplies and barrel it for dispatch by road or rail; such an installation, its whereabouts unfortunately unrecorded, is illustrated in plate 32. The refining and distillation of oil upon which so much of the modern chemical industry is based constantly replaces its obsolete plant and thus leaves few historic installations as milestones to its progress.

30 LIME KILNS (SJ 963884), MARPLE, GREATER MANCHESTER

Lime has been employed from very early times as a component of mortars and cements. It is prepared by the burning of limestone. These impressive kilns, built 1797-1800 by Samuel Oldknow, were worked until early this century. The kilns are 36 feet (11 m.) deep, were toploaded and were cleared from bottom grates by a series of tunnels which vary from 20 (6 m.) to 100 feet (30 m.) in length. They were fired using coal from a nearby pit. Their degree of architectural pretension is most unusual.

RCHM 1970

31 ROSE-IN-VALLEY ARSENIC WORKS (SW 610401), GWINEAR-GWITHIAN, CORNWALL

The production of arsenic in the 19th century was concentrated almost exclusively in Devon and Cornwall, where sulphides of arsenic occur in veins of both lead and copper. The ores were washed, crushed and then calcined, that is reduced to powder by roasting. The arsenic vapour was led off from the kilns through a lambreth or maze of flues and chambers where it condensed. The chemical was then swept out by hand, as shown in this photograph. Workmen in the industry claimed to develop immunity to the effects of arsenic, but their life expectancy was nevertheless extremely short. The English Arsenic Company's Rose-in-Valley Works was established some time before 1873 and closed during the First World War.

? J.C. Burrow c.1900; Royal Institution of Cornwall

31

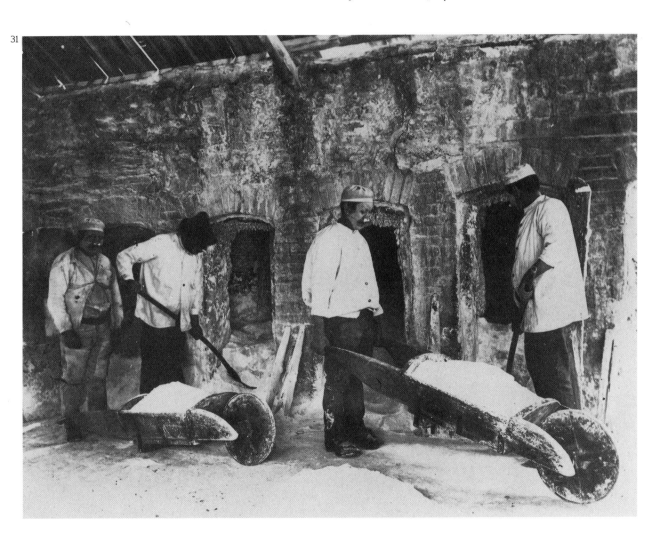

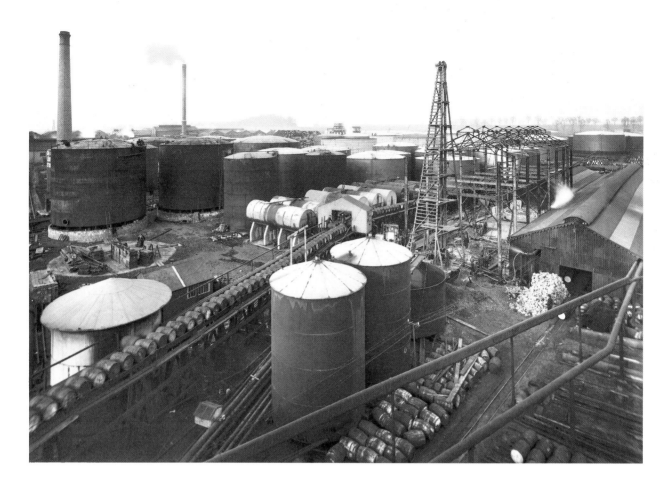

32 OIL TANK FARM

This view was photographed by the famous architectural photographer, Harry Bedford Lemere, who entered his father's photographic business in 1881 when he was seventeen and died, in the office where he had started work, at the age of eighty. Regrettably the location of this early oil depot is not known, but it shows the haphazard way in which such works developed at a time when there was rapid expansion in the use of oil for fuel and the chemical industry. The oil was then still carried in wooden barrels rather than metal drums.

Bedford Lemere 1921

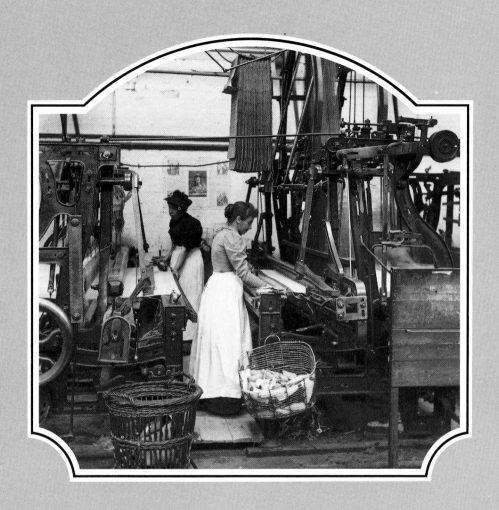

TEXTILES

BLANKET FACTORY (SP 358093), WITNEY, OXFORDSHIRE
H.W. Taunt, 1897; Oxfordshire County Libraries

TEXTILES

ALTHOUGH the spinning and weaving of animal and plant fibres into cloth is one of mankind's earliest manufacturing techniques, for all but the last three centuries most of the processes involved have been conducted at a domestic level, though the trade in its products was by no means domestic in scale. Indeed, throughout most of the medieval period, wool and latterly woollen cloth, were by far the most valuable English exports, but the textile industry's development was beset by both technological and artificial restraints and interferences, causing it to move from urban centres such as Bristol, York and Norwich into the countryside.

From being an urban craft, it became the classic cottage industry organised and capitalized by middlemen in the West of England and East Anglia, and by the artisans themselves in Yorkshire [33]. Attempts to concentrate and mechanize the industry were largely abortive, though water power was successfully applied to fulling in the 13th century. The only further attempt to mechanize – the introduction of the gigmill to raise the nap of cloth – was so resented that its use was banned in the middle of the 16th century and, when re-introduced in the 18th century, it still faced ferocious popular opposition.

The native linen industry, though encouraged by legislation and incentive, involved laborious and fairly obnoxious processes and by the 19th century could not compete with imported raw cotton.

The first development of true factories in the textile industry came not from the main sectors of the industry, but from a luxury branch, the silk industry. This industry at workshop level had flourished in the 17th century, stimulated by an influx of Huguenot refugees. The Spitalfields area of London still displays garret workshops where the industry was first located. It was in Derby, however, that the first attempts at factory production were made. In 1702 Thomas Cotchett installed Dutch spinning machinery in a three storey mill on the River Derwent, and although this venture was not a success it led to Thomas Lombe, a wealthy London silk merchant, starting up production in Derby in 1721. Lombe's factory, which may have been designed by George Sorocold, was of unprecedented size: the spinning mill was 110 ft. (33 m.) long and five storeys high. The machinery was worked by a single large waterwheel. The mill accommodated over 300 workers and part of its fabric survives in a present-day mill which has been converted into an industrial museum.

Although Lombe's mill had no direct imitators, throughout the 18th century there was, in all branches of the textile industry, a move towards concentrating production. In the Nottinghamshire hosiery industry, merchants began to assemble knitting frames in their warehouses where, by 1720, as many as forty apprentices were employed in single premises. In the West of England woollen industry, the workshops which formerly were an integral part of a clothier's house began to be built as separate buildings, a move which accelerated with the introduction of horse-driven machinery later in the century. In Yorkshire large loomshops were built long before the adoption of powered looms; an example in Sowerby Bridge towards the end of the century was over 100 ft. (30 m.) long and was originally four storeys high [34].

33 WELLHOUSE FIELDS (SE 094149), GOLCAR, COLNE VALLEY, WEST YORKSHIRE

The steep valley of the River Colne containing the villages of Golcar, Linthwaite, Marsden and Slaithwaite, was traditionally a centre for the manufacture of woollen cloth. Originally the cloth was made in small domestic units and there were many weavers' cottages on the upper south-facing slopes. The top floors, which contained the looms, have long windows to give the maximum amount of light. Before the early 19th century, cottages, like those forming the terrace in this photograph, were of only two stories, as the weaving room also served as a bedroom. Cloth manufacture was often only a part-time occupation and groups of families might also farm communally, which would explain the presence of the large barn at the end of this row.

RCHM 1983

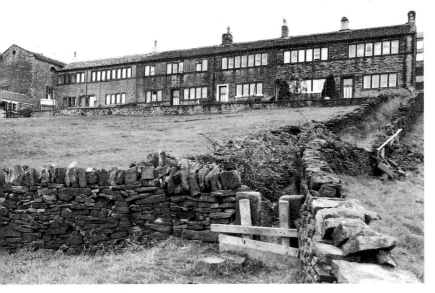

34 SOWERBY BRIDGE MILLS (SE 063236),
WHARF STREET, SOWERBY BRIDGE,
WEST YORKSHIRE

These mills are of considerable significance
in the development of the Yorkshire woollen
industry. By 1792 the owners of Sowerby
Bridge Mills, William and George Greenup,
were carrying out all the necessary steps in
the production of woollen cloth on the same
site. In effect they were operating their
premises as a factory, perhaps the earliest
example in West Yorkshire. The building in the
centre of this view was probably built in the
1790s to house hand looms. Unusually it is
built of brick, and it is possible that the bricks
were brought up the Calder & Hebble
Navigation, opened to Sowerby Bridge in
1770. In the mid-19th century the loomshop
was heightened by a storey and almost
doubled in width.

RCHM 1980

34

A rush of inventions in the latter half of the 18th century was to revolutionize the textile industry, although not in all its branches simultaneously. The cotton industry was the first to benefit. Kay's flying shuttle, Hargreaves' spinning jenny, Arkwright's water frame and Crompton's mule all resulted in greatly increased rates of production; the application of water power to cotton spinning pioneered by Arkwright in 1771 at Cromford in Derbyshire was to herald the factory age. By the turn of the century, water-driven mills had been built throughout the country, many in areas now no longer associated with the cotton industry such as County Durham and Nottinghamshire. After some delay, most of the advantages of powered mechanization were successfully applied to the woollen and flax industries, resulting in a period of intense mill building in Yorkshire and the West of England [35-6].

The development of the rotative steam engine was fundamental to the mill boom of the 19th century. From tentative beginnings at Papplewick in Nottinghamshire in 1785, the improved Watt engine was rapidly taken up in the Pennine counties. By 1800 when the patent expired, some 114 Boulton & Watt engines were in use in the textile industry, 92 in the cotton industry. Alongside the introduction of powered machinery, a gradual change occurred in the factory buildings themselves. The first mills had not differed structurally very much from the multi-storey warehouses that were a feature of most ports. Loadbearing masonry walls, spanned by timber beams and, when of sufficient span, supported by ranks of wooden posts or cast iron columns, carried wooden plank floors. The last decade of the 18th century witnessed a series of trials to make mills fireproof; they began with William Strutt's in Derby, and at nearby Milford and Belper. These mills progressively relegated the structural use of wood and replaced wooden flooring with shallow brick arches supported by protected wooden beams. The

35

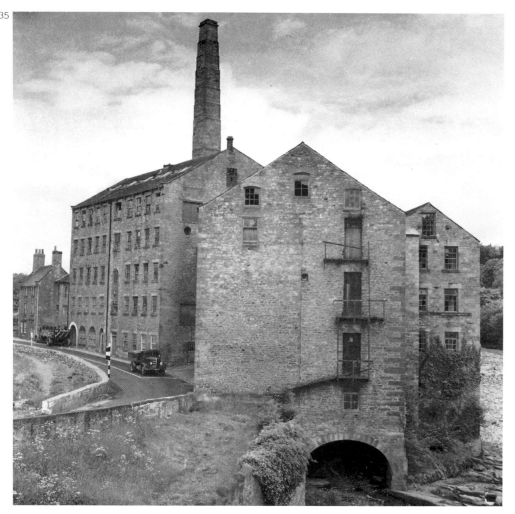

next logical step was to dispense with wooden beams altogether. This occurred at Charles Bage's flax mill at Ditherington in Shrewsbury in 1797 where all wooden components, including the roof framing and doors, were replaced by iron members. This, the world's first iron-framed building, still survives, although now in use as a maltings. Other early so-called 'fireproof' mills survive at Belper (1804), Whitehaven (1809), Cumbria, and Kings Stanley (1813), Gloucestershire, all showing somewhat different solutions to problems of roof span and power transmission. Iron-framed, fireproof mills did not, however, completely replace wooden-floored mills. Indeed, they remained the exception throughout much of the 19th-century building expansion, and only became the norm with the advent of wrought iron and, somewhat later, rolled steel beams. These materials allowed the external walls to carry less load and larger areas of wall could be devoted to glazing [37].

35 ULLATHORNE'S MILL (NZ 047165), STARTFORTH, DURHAM

This impressive mill, which was built in 1760 to spin flax, is situated on the River Tees opposite Barnard Castle. It was originally powered by a large inside water wheel, but was later converted to steam. Enlarged in the 19th century, the mill continued in use making twine and shoe-thread until the 1940s.

Eric de Maré 1956

36 HEBDEN BRIDGE, HEBDEN ROYD, WEST YORKSHIRE

Hebden Bridge grew up around the ancient bridge over the fast-flowing Hebden Water; there were many small textile mills which depended upon water for their power. The stone terraced houses, ranged along the steep hillsides, are often double: a lower house comprises two floors; two upper floors, entered from the hillside behind, form a 'top' house. In the centre of the photograph is Nutclough Mill (SD 996276). The present building dates from about 1880, but it incorporates a late 18th century core. From 1873 to 1918 the Mill was the home of the Hebden Bridge Fustian Manufacturing Society, an early workers' co-operative. Further up the hillside new terraced housing is under construction and above that the New Birchcliffe Chapel is nearly complete.

c.1898

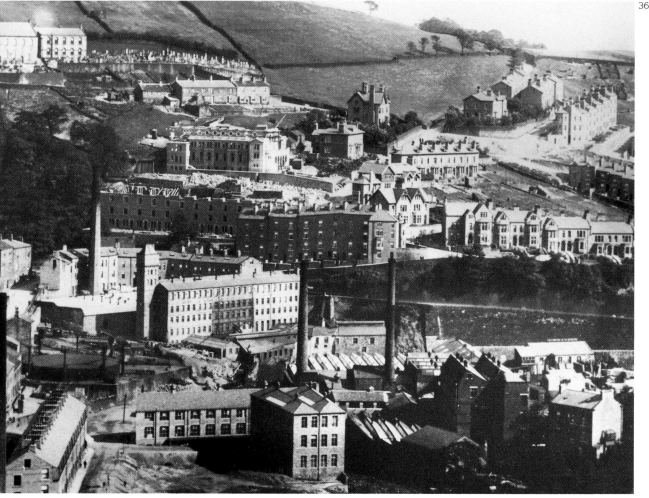

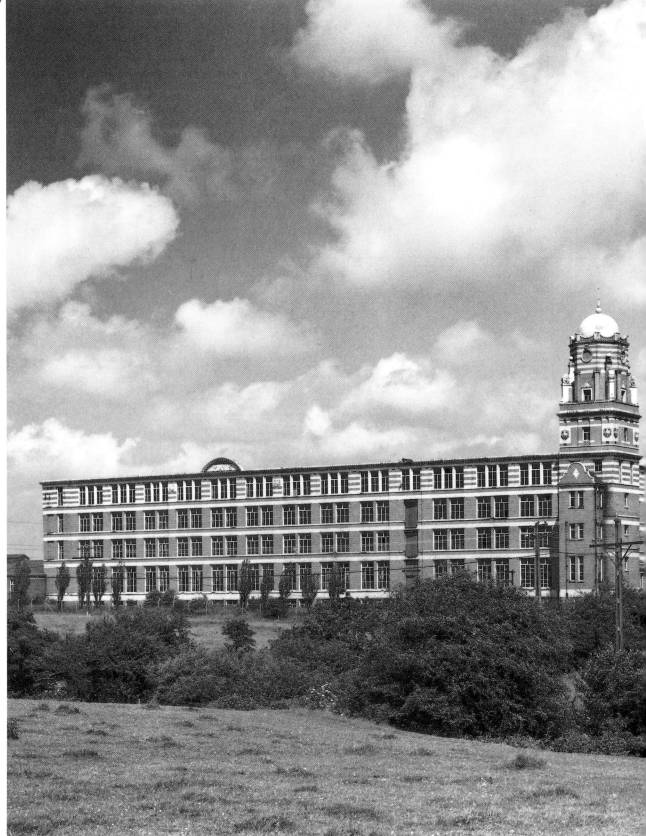

37 RING MILL AND MAVIS MILL (SD 563147), COPPULL, LANCASHIRE

South-east Lancashire specialized in cotton spinning. The peak of production came shortly before the First World War when some 85% of the cloth produced in Lancashire was exported. In the early years of the 20th century huge cotton-spinning mills, like the two illustrated here dating from 1906, were constructed containing as many as 100,000 spindles. These late mills were usually built of brick, often with faience and terracotta decoration. The towers contained water tanks for the fire sprinkler systems.

RCHM 1966

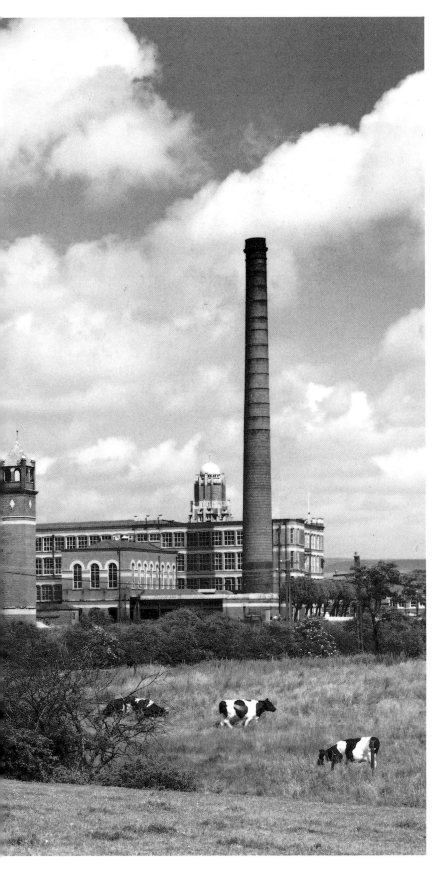

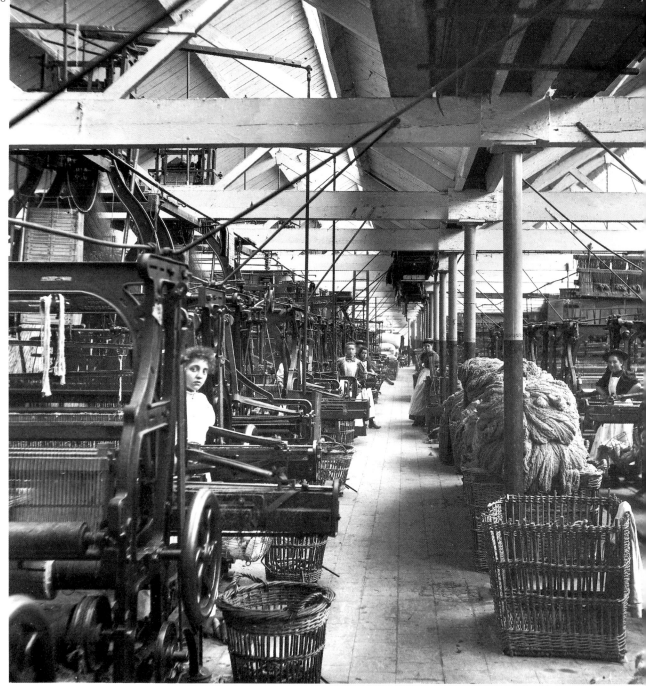

38 BLANKET FACTORY (SP 358093), WITNEY, OXFORDSHIRE

Witney has long been famous for the manufacture of blankets. References to the woollen industry in the town go as far back as the 10th century; blanket-making possibly existed in the 14th century when this type of cloth was supposedly invented by one Thomas Blanket, although this derivation of the name is actually apocryphal. In 1710 the Company of Blanket Weavers was granted a charter, and from at least this time members of the Early family were engaged in the blanket industry: Thomas Early was the second Master of the Company, and of the six chief manufacturers in 1852, five were Earlys. This photograph is one of a long series commissioned in 1897 by Charles Early to record the complete process of manufacture; the results were used to illustrate a guide to his mills published the following year. At the turn of the century some 400 people were employed by Charles Early & Company, about half the number engaged in the Witney blanket industry.

H.W. Taunt 1897; Oxfordshire County Libraries

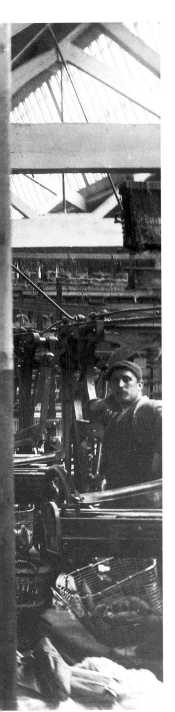

THE successful application of power to weaving had taken somewhat longer than with spinning. Cartwright's loom of 1784 was not an immediate success and it was not until 1813, after many modifications and refinements, that power looms became significant. From then on their numbers rapidly increased with catastrophic effects on the cottage-based hand-loom weaving industry. As power looms increased in size, they brought into being a new form of building, the distinctive, vast, single-storey sheds with glazed north lights and ridge-and-furrow roofs [38].

The early hosiery workshops in some cases survived as small scale enterprises until the 20th century [39] but economies of scale in the garment industry became apparent in the latter half of the 19th century and large custom-built factories became a feature of cities such as Leeds [40]. The 20th century has seen a dramatic contraction of the industry and hundreds of characteristic mill buildings are now empty or put to other uses. Meanwhile garment-making has flourished in areas such as the South East [41], distant from the traditional centres of the industry.

39 FRAMEWORK KNITTERS' WORKSHOP (SP 603988), 42-44 BUSHLOE END, WIGSTON, LEICESTERSHIRE

The hosiery industry was widespread in the East Midlands and unlike most other textile trades maintained an almost exclusively domestic system of production until the middle of the 19th century. In 1844 the village of Wigston, for example, had 550 stocking frames in small workshops. The frameshop in this photograph is a unique survival. It forms part of a small complex comprising house, retail shop, seaming room and frameshop for knitting gloves; it was built about 1880 and the ground floor machines, seen here, were last worked in 1952. On the floor above are five hand-operated Griswold machines for making socks, last used in 1914.

RCHM 1972

39

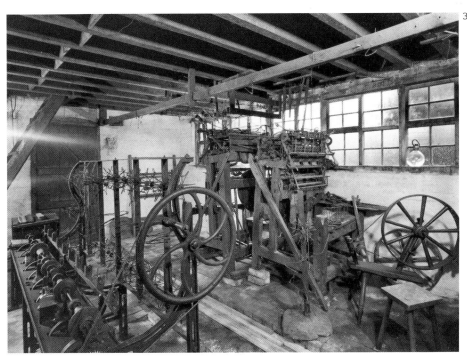

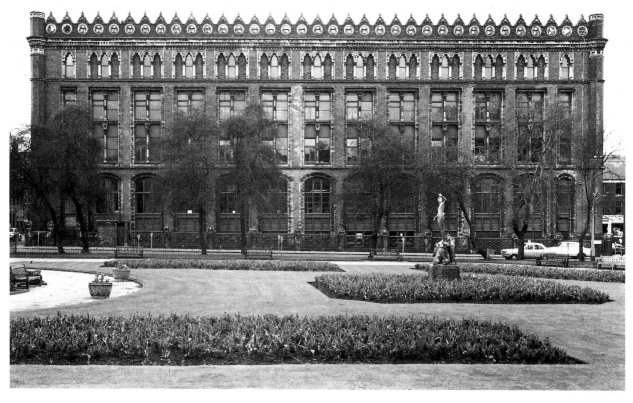

40 ST PAUL'S HOUSE (SE 296337), ST PAUL'S STREET, LEEDS, WEST YORKSHIRE

A pioneer ready-made clothing factory, designed by Thomas Ambler in 1878 for the Leeds manufacturer, John Barran. Built of brick in the Hispano-Moorish style with Doulton terracotta decoration, the factory was obviously meant to impress. This photograph was taken when the building had become somewhat dilapidated. It has since been restored and converted into offices.

RCHM 1970

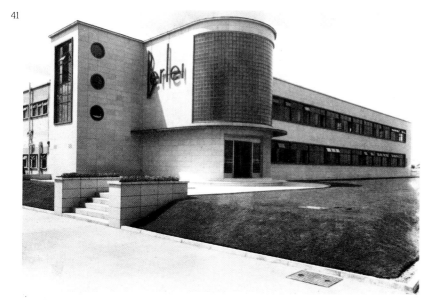

41 BERLEI FACTORY (SU 958803), BATH ROAD, SLOUGH, BERKSHIRE

The company which was to become Berlei Ltd. began in 1907 in Syndey, Australia. In 1912 the business was taken over by the brothers Fred and Arthur Burley, and they established the *Berlei* trademark which led to the renaming of the company in 1919. They opened a showroom in London in 1934, and offices and a factory at Slough quickly followed. Their International Modern style factory, built in 1936-7, was designed by Sir John Brown & A.E. Henson in association with W. David Hartley. It was demolished in 1984.

Herbert Felton 1937

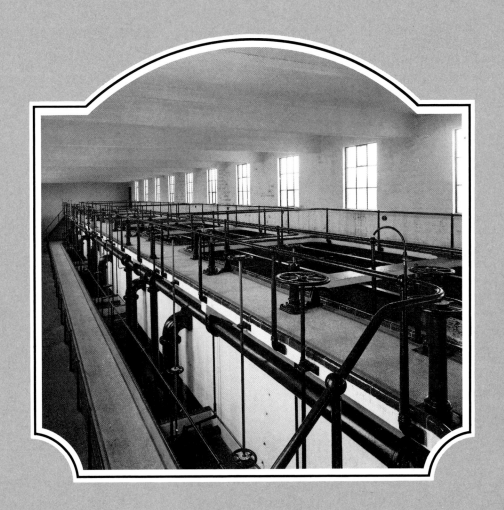

PUBLIC UTILITIES

WHITACRE WATERWORKS (SP 215912), SHUSTOKE, WARWICKSHIRE
Bedford Lemere 1919

WATER SUPPLY AND DISPOSAL

UNTIL the rapid urbanization in the 19th century, the corporate provision of public services was but a minor concern. From earliest times most settlements had been sited with regard to adequate water supplies from wells, springs and streams and only in exceptional cases, such as London, had there been any significant investment in water supply systems. Indeed, the history of London's water supply is, in many ways, the early history of the industry itself.

London's supply was traditionally taken both from public wells, such as Holywell, Clerkenwell and Clements Well, and from the Thames and its tributary rivers whence, as early as 1236, it was distributed by conduit to public cisterns in Westcheap and Dowgate. In 1582 Peter Morrys, a Dutchman, installed a water driven pump in one of the arches of London Bridge and later extended his system to a further three arches. This installation survived despite competition from the New River until the bridge was replaced in 1831. The New River, a conduit some 40 miles (64km.) long bringing water from Hertfordshire, was originally conceived as a public venture but was undertaken by a private individual, Hugh Myddleton, largely at his own expense. It opened in 1613, only five years after work had started, and traces of the Round Pond as well as later reservoirs and pumphouses can still be seen at New River Head, Rosebery Avenue, Islington. The aqueduct, considerably straightened in the 19th century, still carries water. Further private waterworks companies followed, such as the York Buildings Waterworks Company in 1691 and the Chelsea Waterworks in 1722; a century later nine separate Companies served the metropolis. The advent of steam pumping from deep wells greatly increased the capacity to supply water and it was through this method that provision was made for many cities far removed from upland reservoirs. Once again London led the way and, as witness, at Kew Bridge pumping station is preserved an unrivalled collection of steam engines dating from 1820 onwards. Some of its smaller steam pumping stations such as Addington Well, Croydon [42], have been demolished in recent years, although in this instance the A-frame beam engines of 1888 and 1893 have been preserved elsewhere.

In other cities, towards the middle of the 19th century many of the small private water companies were bought out and municipal undertakings

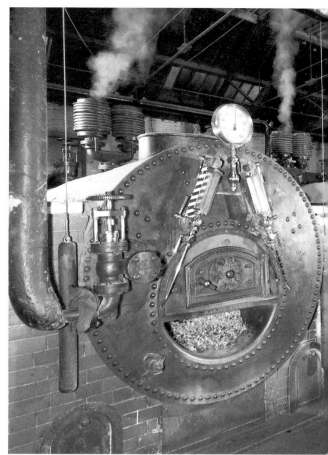

42

established. In Liverpool, for example, the two existing private companies were taken over by an Act of 1847 and a major new scheme incorporating the former installations was begun (1852). This included the Everton Waterworks designed by Thomas Duncan which comprised an Italianate engine house, a covered reservoir and a massive water tower 90 ft. (27 m.) high [43].

Throughout the 19th century rotative beam engines continued to be used and developed for water supply long after they had been superseded by different types of steam engine in other industries. Indeed many of the finest beam engines ever built were constructed in the latter part of the century and some, including those at Goldstone (1866), near Brighton, and Papplewick (1884), Nottinghamshire, have been preserved as monuments to this phase of technology.

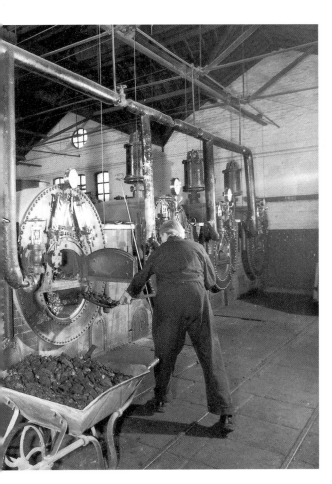

42 ADDINGTON WELL WATERWORKS (TQ 373638), FEATHERBED LANE, CROYDON, GREATER LONDON

The engine house of 1888 by Thomas Walker, Borough Engineer, has two beam engines by Easton & Anderson, 1888, and the Glenfield Company, 1893. This photograph was taken when the boilers were still being fired by hand. In providing information perhaps not otherwise available, record photographs like this of work in progress are even more valuable than illustrations of buildings or machinery long abandoned.

RCHM 1973

43 EVERTON WATERWORKS (SJ 361918), AUBREY STREET, LIVERPOOL, MERSEYSIDE

Provision of public water supply had been largely undertaken by private enterprise until the middle of the 19th century, when most large towns took over the small private water companies. There followed a huge capital expenditure on civil engineering works, such as reservoirs and pumping schemes. Buildings like the waterworks in this photograph, designed by Thomas Duncan in 1857, were tangible expressions of Victorian civic pride.

RCHM 1974

43

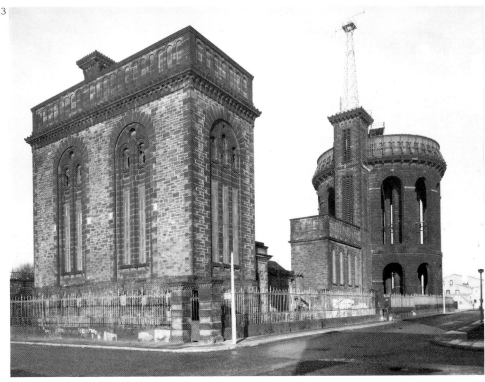

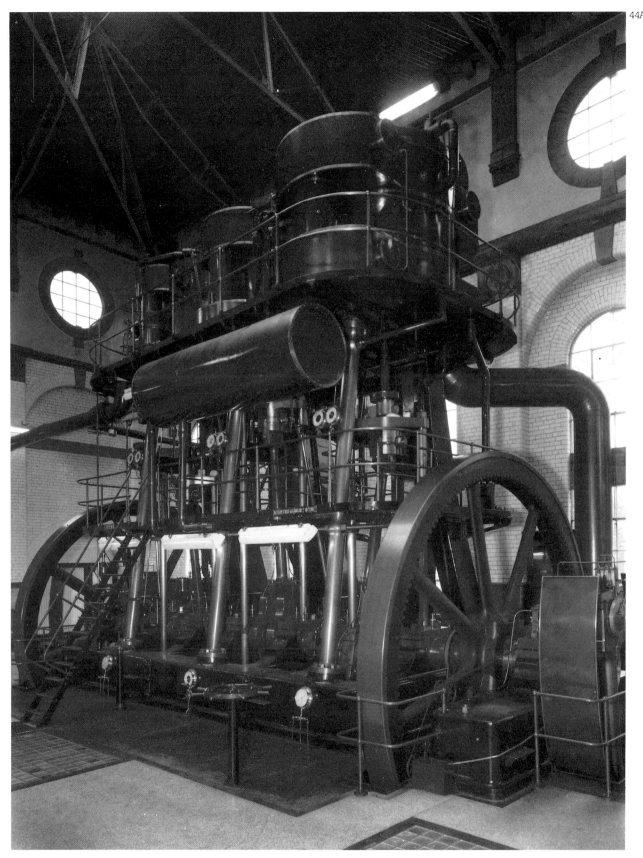

UNTIL well into the 20th century steam engines continued to provide the cheapest and most reliable means of pumping. Many impressive pumping stations were built to house marine type vertical triple expansion engines, as at Elkesley near Retford in Nottinghamshire [44], and at several locations in London. The latter includes Kempton Park, the largest of all such installations with engines and pumps of a combined height of 76 ft. (23 m.) and an output of over 1000 hp per engine. Electrically driven submersible pumps have entirely replaced steam pumps in recent years and, as they require little more than a shed to accommodate them, a great many fine pumping stations are now redundant.

The disposal of waste was usually, in theory, controlled by local ordinances but generally there was little physical provision; systems of open gutters channelled effluent into the nearest convenient stream or river. In areas where night soil was valued as a fertilizer or where urine was collected for use in the woollen industry, some collection was provided, albeit for commercial and not health reasons. The ravages of cholera and typhoid in the middle of the 19th century, despite a reluctance to recognise the cause, forced municipalities to take some action.

In London the Metropolitan Board of Works was created in 1855. Joseph Bazalgette was appointed as its engineer. His solution was to construct two great deep sewers, the Northern and Southern Outfalls, running parallel to the Thames and intercepting the traditional sewers running at right angles to the river. The Southern Outfall terminated at Crossness in Kent where an extravagantly detailed pumping station was built to house four 125 hp beam engines.

The completion of the installation in 1865 was recorded by a series of photographs [45]. The buildings have now lost their freshness but the engines, although last used over thirty years ago, survive. London's experience was echoed in many cities throughout the country and other fine beam engines have been preserved at Leicester, Shrewsbury and Portsmouth.

44 PUMPING STATION (SK 664760), ELKESLEY, NOTTINGHAMSHIRE

This station was built, 1909-11, to provide a new water supply for the city of Lincoln. Its two triple-expansion steam engines were manufactured by Ashton Frost & Company of Blackburn. The engine in the photograph, named *Livens*, was started on 9 August 1911. This is one of a series of record photographs taken when the future of this pumping station was in doubt.

RCHM 1973

44B

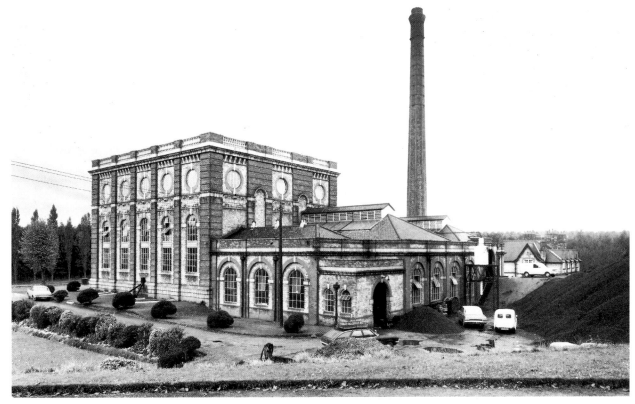

45 CROSSNESS PUMPING STATION
(TQ 484811), BELVEDERE ROAD, BEXLEY,
GREATER LONDON

This pumping staton is at the end of the
Southern Outfall Sewer, 1860-2. The original
buildings together with the entire sewerage
system for London were designed by Sir
Joseph Bazalgette. The engine house, built
1862-5, is now disused, but it still contains its
four beam engines by James Watt & Son,
which were converted to triple expansion by
Goodfellows in 1899. This is one of a number
of photographs taken to show the progress on
construction up to, and including, the opening
ceremony.

c.1865

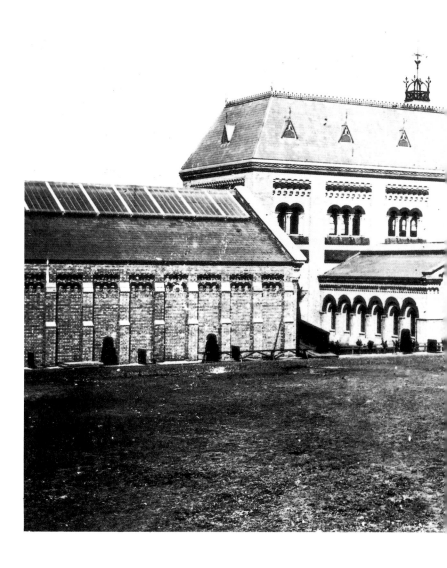

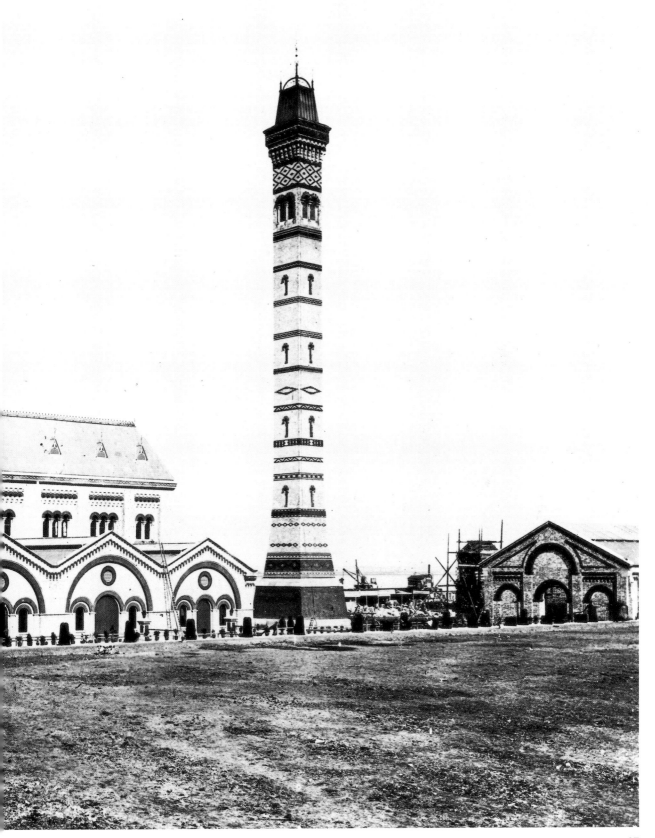

GAS

THE possibility of using gas for public lighting was suggested as early as the mid-18th century by Carlisle Spedding, the inventive mining engineer. He proposed piping methane from Saltom Pit to Whitehaven, but little seems to have come of the idea. William Murdock is credited with the first practical demonstration of the potential of gas produced from coal when he lit a room of his house in Redruth in 1792. Murdock was an employee of Boulton & Watt and in 1802 the firm's Soho works in Birmingham were lit by gas, its first significant use. Over the next decade Boulton & Watt installed gas lighting systems, as well as engines, in mills throughout the country.

In 1812 the Gas Light and Coke Company was established in London to supply individual customers from a central gas works; such was its success that within three years it had laid 26 miles (41.5 km.) of mains. Gas was initially only used for lighting; its potential for cooking, heating and power was not effectively realized until its dominant position as a light source was threatened at the end of the century and forced the industry to develop other markets.

The earliest gasworks comprised banks of hand-fed horizontal retorts; such retorts survived in small rural gasworks such as Fakenham in Norfolk until superseded by natural gas [46]. Ironically this elementary system outlived its more sophisticated descendents, i.e. inclined retorts, popular at the turn of the century, and vertical retorts used in most large 20th-century works. Gasholders, the familiar sign of a gasworks anywhere, have also survived as storage and regulating tanks for natural gas long after their associated plant has been scrapped.

46 GASWORKS (TF 919293), FAKENHAM, NORFOLK

In 1812 the first company selling gas from a central generating station through mains to independent consumers was formally established. This was the Gas Light & Coke Company in London. Fakenham gasworks was opened in 1825, but the retort house dates from 1846, the year when street lighting was introduced in Fakenham. This is the last small town gasworks surviving in England and, although it closed in 1965, it is to be preserved as a museum. The photographs show part of the retort bench and a gasholder, dated 1888.

F.J. Palmer 1965

46A

47A

47 ELECTRICITY GENERATING STATION (SJ 314888),
CRAVEN STREET, BIRKENHEAD, MERSEYSIDE

The development of the electricity supply industry and the building of
local generating stations led to a rapid change to electric power for
tramways after 1900. Birkenhead, which had one of the earliest
sytems of horse trams in Britain, starting in 1860, laid new lines and
built this generating station. The works were carefully documented by
taking progress photographs throughout the construction and
finishing, in 1901, with the Board of Trade inspections.

1901

ELECTRICITY

ALTHOUGH small electric generators were first developed in the 1830s and arc lamps in the 1850s, the commercial potential of electric lighting was not exploited until 1880 when the incandescent filament lamp was devised. This lamp was much more suitable for general use. Public street lighting appeared in Godalming, Surrey, in 1881, and the following year the Holborn Viaduct generating station provided street lighting in the surrounding area. In 1887 the London Electric Supply Corporation was established and within a few years current was transmitted from Ferranti's huge Deptford power station. In the succeeding decade most towns and cities invested in generating plant which was usually quite modest in size when only lighting was required, but could be quite large when power for electric trams was also supplied [47].

The rate of obsolescence in the industry is such that most generating plant had a relatively short life. Already in the first decade of the 20th century, steam turbines replaced reciprocating steam engines, while the large, prestige coal-burning power stations of the inter-war years have now been phased out [48].

47B

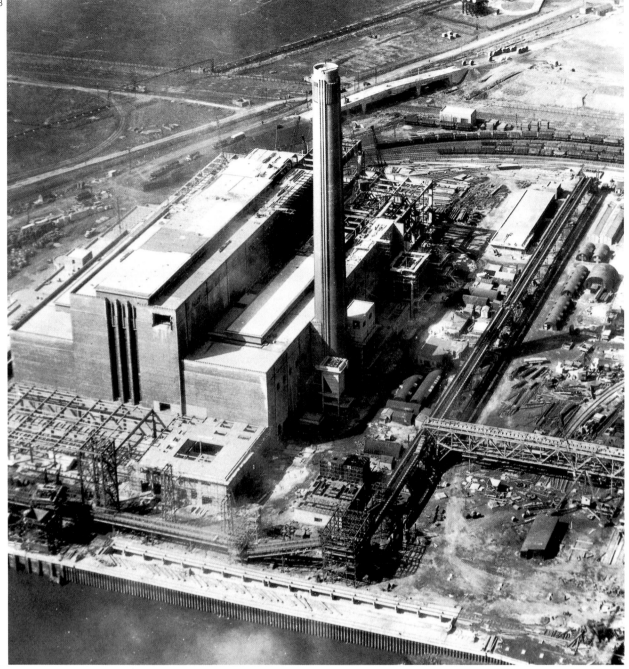

48 NORTH TEES POWER STATION (NZ 478214),
HAVERTON HILL ROAD, BILLINGHAM, CLEVELAND

Sir Giles Gilbert Scott is probably best known for being the architect of
Liverpool Anglican Cathedral and Battersea Power Station; it was said
that in the space of thirty years he designed two cathedrals, one for
God, and one for Electricity. North Tees Power Station is a late
example of the great brick generating stations for which Scott had
set the pattern and for which he was consultant architect. This is one
of a series of air photographs taken in the early 1950s to show
progress on construction. The power station was operational for less
than thirty years.

Central Electricity Generating Board

TRANSPORT

WEYMOUTH QUAY STATION (SY 683788), WEYMOUTH, DORSET

Edward Woodward c.1900

ROADS

THERE have been several unrelated periods of planned new road construction in England, most notably during the Roman occupation when some 5,000 miles (8,000 km.) of road were built. The Commissioners' roads of the Enclosure Acts, the Carlisle to Newcastle military road built in the aftermath of the Jacobite Rebellion of 1745 and the 20th-century bypass and motorway programmes [49] were further such episodes. Isolated examples of new road construction also occurred in the turnpike era, such as the Holyhead Road and the Black Dog Trust road for 12 miles (19 km.) south of Bath undertaken in 1815 and 1834 respectively, but both these projects were undertaken too late to have any imitators and the railways effectively put an end to new road construction for a century.

People, goods and traffic clearly moved around the landscape of pre-Roman England but it is much more difficult than many seem to realise to recognise, define and date early trackways. It is far too naive to claim their existence two thousand and more years ago on the basis of a cross-country track existing now between hillforts or beside burial mounds and no acceptable evidence whatsoever supports the belief that prehistoric man was guided by imaginary so-called ley-lines. Nevertheless, given a landscape extensively cleared in some areas, forested in others, and overall enjoying only natural drainage, it is possible to detect in a study of topography and archaeological evidence a pattern of long-distance routes following natural features such as ridges and escarpments while making for relatively easy fording and ferrying points across England's many rivers and streams. Salisbury Plain, for example, can be argued to be the focus of several such routes, each difficult to pinpoint, winding their way from east, north east and south west. Unequivocal evidence for prehistoric tracks comes, however, at a much more detailed level of study. The best examples, currently being recorded, have been preserved in the peat of the Somerset Levels – remarkable survivals in timber of varied construction joining the islands of the Brue Valley and islands to the Polden Hills in a complex originating in the fifth millennium BC. Many miles of 'country lane' are also known among the developed landscapes of the second and first millennia BC, surviving in upland areas like Dartmoor and recorded on air photographs over much of the arable areas of England where they have been razed.

49 M4 MOTORWAY AND ROMAN ROAD (SU 345744), BERKSHIRE/WILTSHIRE

This air photograph shows the view looking west over the Berkshire county boundary towards Baydon, Wilts., where the motorway crosses a Roman road, Ermin Street, running from Silchester (*Calleva Atrebatum*) to Cirencester (*Corinium*).

The vast increase in the use of motor transport in the 20th century led to the development from the mid-1950s of a system of motorways. The first was the M1, a section of which opened in 1959. The M4 from London to South Wales was constructed through Berkshire and Wiltshire in 1971-3. Its sinuous course reflects a series of constraints - environmental and the needs of high-speed driving - absent from the thoughts of the Roman engineers whose road is much the straighter. At the intersection, the M4 sliced through a settlement alongside the latter.

RCHM 1975

SUCH a rural pattern continued in Roman times, inevitably slashed in places by straight military roads like Ackling Dyke in Dorset and Wade's Causeway, North Yorks [50]. This last exemplifies the later abandonment of many lengths of such roads, but the development of a largely unco-ordinated though locally-useful pattern of roads and tracks in medieval times absorbed where appropriate bits and pieces from earlier lines of communication. Responsibility for upkeep and safety came generally to rest with the parish where, despite a national interest in a few major routes passing through many of them, e.g. between London and York, the prime concern was access to its own fields, woods and quarries and to the neighbouring settlements.

The development of the turnpike system was a response to increasing trade in the 17th and 18th centuries. The first Acts to improve existing roads by charging tolls were passed in the late-17th century, but the first turnpike trusts were created in the first decade of the 18th century. Early turnpikes concentrated around London and the cloth-producing towns of the West Country, but by the end of the century several thousand trusts administered some 20,000 miles (32,000 km.) of improved road throughout the country. The most obvious features of these roads were the milestones and tollhouses. The collection of tolls continued on turnpike roads until the late 19th century [51] and, indeed, still survive on some privately-owned roads and bridges.

The great contribution of the turnpike trusts was to introduce a scientific approach to the construction and maintenance of the roads themselves. Engineers such as Metcalf, Macadam and Telford were employed to survey and lay well-drained, firm road surfaces. Their methods and materials varied somewhat but the resulting improvement to road transport was striking as attested by the achievements of the mail coaches in the early 19th century. Macadam's system of using well-consolidated broken stone because of its relative cheapness became the most popular method of road construction and lent itself easily to later improvements using tar and asphalt [52].

50 WADE'S CAUSEWAY, WHEELDALE MOOR, EGTON, NORTH YORKSHIRE

The spectacular remains of a Roman road on the North Yorkshire Moors looking south-west from SE 809984. This road was probably begun about AD 79 as part of the Roman army's plan of consolidation of the area north of Malton (*Derventio*).

Raymond H. Hayes c.1937

50

51 KENNINGTON GATE (TQ 313777), LAMBETH, GREATER LONDON

Until the 1860s there were 117 toll-gates remaining within six miles (9.5 km.) of Charing Cross. These were a relic of the days when turnpike roads had been funded by statutory trusts. By the middle of the 19th century these toll-gates 'were a blot upon metropolitan civilization and the most odious of taxes' (Harold Clunn). Kennington Gate was removed on 18 October, 1865 and by November of that year the sixty gates remaining in south London, with the exception of Dulwich, had also been removed. Horse-buses, like the one in this photograph, survived on the streets of London until 1916.

Howarth-Loomes Collection 1860s

52 ROAD MAKING

A large number of workmen are engaged in laying a new road surface. At such a late date, apart from the tipper-truck, no mechanical help is used for a task which would now be carried out almost exclusively by machines. The exact location of the road is not known, but it may be the Belsize Park area of London.

Bedford Lemere 1920

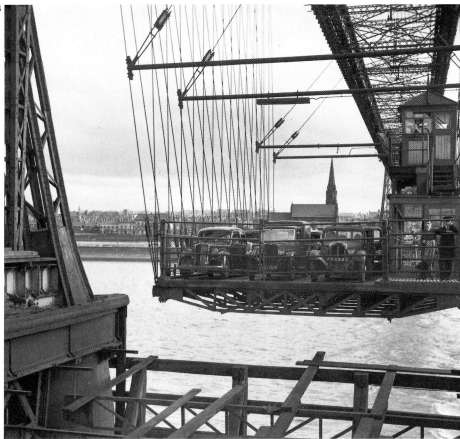

B RIDGES are perhaps the most striking features of the road system.
Until the latter part of the 18th century, major bridges were either
wooden or masonry-arched in construction. The spectacular
introduction of cast iron as a constructional material with the Iron
Bridge in Shropshire in 1779 heralded an heroic age of bridge
building. All the great engineers of the day were involved in bridge
building to some degree; Thomas Telford proved his versatality by
building notable masonry, cast-iron and suspension bridges. The
products of many of these feats of engineering have survived and
indeed, later in the century, the construction of large bridges attracted
the attention of photographers with the result that bridges are perhaps
the most photographed of all road features. Where routes crossed
navigable waterways, attempts were made to minimize the
interruption to navigation. Swing bridges were the most common
solution but chain ferries and transporter bridges were also used [53].
Latterly high-level bridges with long approach viaducts have been built
to span major rivers.

53 TRANSPORTER BRIDGE (SJ 509838), RUNCORN/WIDNES, CHESHIRE

Four transporter bridges were built in Britain, of which this was the first, designed to allow the least possible obstruction to shipping where a high-level bridge was impractical. A moveable platform was slung by cables from the steel framework and carried passengers and vehicles from one side to the other. This transporter bridge was built 1901-5 by the Widnes & Runcorn Bridge Company and spanned 1000 feet (300 m.) across the River Mersey at the lowest bridging point on the river. It has been replaced by a new road bridge, opened in 1956.

Eric de Maré 1954

INLAND NAVIGATION

C OASTAL and inland navigation have been fundamental to trade,
industry and military movement since prehistoric times. The 'blue
stones' of Stonehenge were almost certainly transported by water from

south west Wales while the Romans certainly made great use of water transport in their military campaigns and in the Fens, dug the first canals in the country. Successful medieval cities like Norwich, Bristol and Newcastle were inland ports on rivers and it is no accident that most of the areas of industrial expansion of the 16th and 17th centuries were related to river navigations too. It was attempts to improve these navigations in the earlier 18th century that gave rise to a body of engineering expertise which was to be so important to the development of the canal system in the latter half of the century. Many of the earliest canals, such as the St Helens and the Stroudwater in Gloucestershire, were merely deadwater equivalents of rivers parallel to them, but the Bridgewater Canal introduced two novel elements, namely aqueducts across other waterways and tunnels through local watersheds. By the end of the century, a network of canals had been built linking all the major river navigations, but there were distinctive components of the system. The canals of the north, south and east were generally broad canals taking barges up to some 14 ft. (4 m.) in width [54] but the canals in between, focussed on Birmingham, were built to a 7 ft. (2 m.) gauge. This width had been settled on by James Brindley when he had to build locks on the Staffordshire & Worcestershire Canal; probably uncertain water supplies led him to so narrow a gauge for he was certainly well aware of the broader locks elsewhere.

54 SUMMIT LOCK AND BASIN (SO 938034), DANEWAY, BISLEY-WITH-LYPIATT, GLOUCESTERSHIRE

Proposals to provide a cross-country route by connecting the River Severn with the Thames had been current since at least the 17th century. The Thames & Severn Canal was constructed to link the Stroudwater Navigation, opened in 1779, with the Thames at Lechlade. The lock seen through the arch of the bridge in this photograph marks the highest point on the canal and for two years the basin at Daneway was the terminus before the opening of the nearby Sapperton Tunnel in 1788. Construction of the Thames & Severn Canal had begun in 1783 and the first boats passed through to the Thames six years later. After many difficulties in the late 19th and early 20th centuries, the canal was finally abandoned in 1933.

H.W. Taunt 1904; Oxfordhsire County Libraries

55 THREE LOCKS (SO 867938), BRATCH, WOMBOURNE, STAFFORDSHIRE

The Staffordshire & Worcestershire Canal descends into the Smestow valley by means of this unique flight of locks by James Brindley and Thomas Dadford, opened in 1772. Originally built as a staircase, it was later altered to a flight of three locks with very small pounds between, and served by, a complicated system of side ponds. There is an equally complex series of steps and towpaths. The octagonal toll-house in the photograph is situated beside the top lock.

Staffordshire County Council 1969

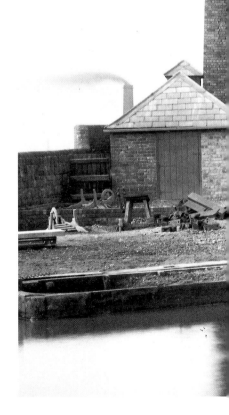

Brindley built his first lock c.1770 at Compton in Wolverhampton, followed by the flight of locks at Bratch in Staffordshire a few miles to the south [55].

In addition to the narrow and broad canal systems, there was a tub boat system. In this, stretches of canal were linked by lifts or inclines by which tub boats, usually some 20-26 ft. (6-8 m.) long, could be transferred from one level to another. The canals using this technique were peculiar to hilly areas where the use of locks would have been too expensive. Most such tub boat canals were in the South West but a small, important system of this type serviced the iron-making areas of the Shropshire coalfield, linking them to both the River Severn and the conventional canal system [56].

In the 19th century, a great many improvements to river navigations were carried out, especially in the north. Ship canals were also constructed, such as the Gloucester and Sharpness Canal completed in 1826 to re-establish Gloucester as an inland port [57]. The most spectacular of these was the Manchester Ship Canal, opened in 1894; Manchester speedily became one of the major ports in the country.

56 TRENCH INCLINE (SJ 691122), OAKENGATES, SHROPSHIRE

The Incline was 223 yards (203 m.) long and connected the
Shrewsbury Canal, opened in 1797, with the Wombridge Canal, some
75 feet (23 m.) higher. The boats were carried in cradles and the
photograph shows an empty tub-boat arriving at the top. Originally
worked by counterbalance, a steam engine was only used to pull the
cradles over the top of the plane. However, in 1842 a more powerful
engine was installed. The Trench inclined plane remained in use until
1921, the last in Britain.

c.1910

56

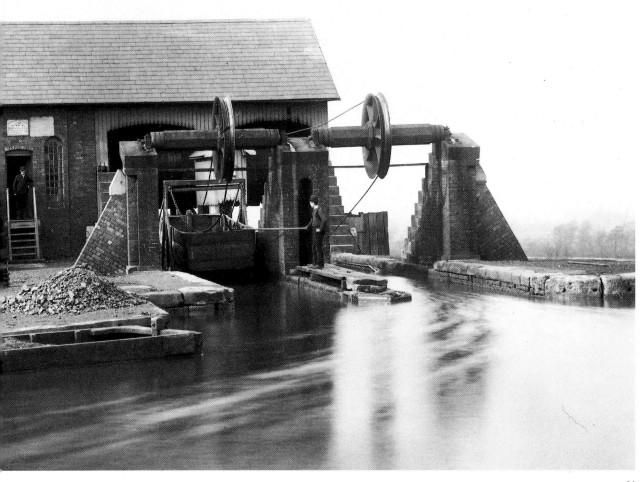

57 DOCKS (SO 827182), GLOUCESTER, GLOUCESTERSHIRE

An Act of Parliament was passed in 1793 which authorized an ambitious scheme to construct a canal bypassing sections of the River Severn and to build a dock which would promote Gloucester as a port to rival Bristol. Robert Mylne was appointed Chief Engineer and work began in 1794. The main dock basin was completed in 1799 but it did not come into use until 1812. Gloucester docks prospered in the mid-19th century with the growth of the corn and timber trades. This photograph shows timber being unloaded at Romans' Timber Yard, adjacent to Llanthony Warehouse, 1873 (*right*). On the opposite side of the Main Basin may be seen (*from left to right*) the Great Western Warehouse, 1863, Fox's Malt-house, 1888, and Alexandra Warehouse, 1870.

Sidney Pitcher c.1925

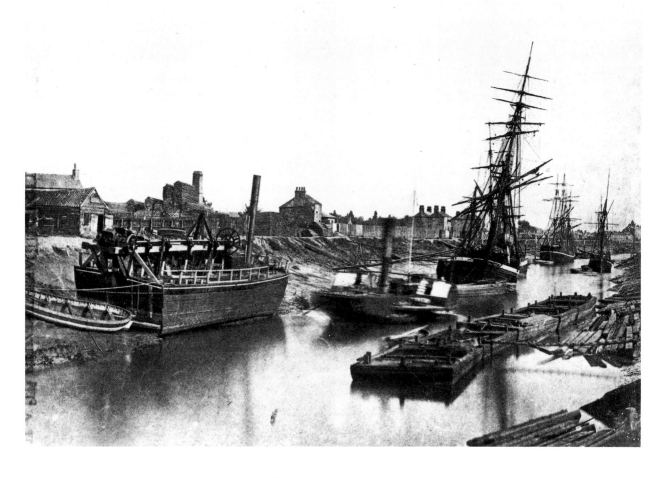

58 RIVER NENE (TF 457105), WISBECH, CAMBRIDGESHIRE

The prosperity of Wisbech depended upon the River Nene, which was both a navigable channel to the sea and a main drain for a large area of Fenland. An Act of Parliament was passed in 1852 to put into effect the plans of James Rendel to embank the river at Wisbech and remove the worst bends and shoals. Work began in 1854 and a local photographer, Samuel Smith, recorded every stage of construction. This view shows the Nene near Horseshoe Corner and the dredging machine which was destroyed by fire in 1855.

Samuel Smith c.1854

PORTS

COASTAL and international trade has been of increasing importance to the English economy since late prehistoric times, but it was not until the early 18th century that significant improvements were introduced to facilitate the berthing of vessels and the handling of cargo. Before this, all trade was accommodated by simple tidal wharfs where, in areas of high tidal range, vessels were grounded twice a day [58-9]. Although wet docks, that is docks in which water was impounded between tides, had been constructed in naval dockyards [60] in the 16th century, no mercantile wet docks where vessels could be discharged existed until a dock was built at Liverpool in 1710. The considerable success of this dock encouraged further docks to be constructed, first at Liverpool and then at Hull, Lancaster, London and Bristol. By 1830 some 370 acres (148 ha) of wet docks had been built in England. Such provision both facilitated the handling of cargo and increased security by eliminating the need for transhipment by lighter. In the 19th century security was further strengthened by the introduction in 1800, at the West India Docks in London, of the closed dock system in which the docks and their warehouses were surrounded by high walls with just a few supervised gateways.

59 NORTH PIER LIGHTHOUSE (NX969187), WHITEHAVEN, CUMBRIA

Whitehaven is remarkable as a planned town of the late 17th century. The harbour was developed over more than two centuries commencing with the construction of the Old Quay in 1634, one of the oldest remaining coal wharves in Britain. The harbour is enclosed by two pairs of converging piers. The 18th century inner harbour, which remains tidal, handled the vast coal and overseas trade. The outer harbour works, for which Sir John Rennie was consultant engineer, were begun in 1824-39 when the New West Pier was built; this is seen in the background of the photograph. In the foreground is the North Pier Lighthouse, 1841.

RCHM 1970

60 NUMBER 3 COVERED SLIP (TQ758692), ROYAL NAVAL DOCKYARD, CHATHAM, KENT

Naval Dockyards are among the earliest examples of large areas developed for intensive industrial use. The end of No.3 Covered Slip, facing the River Medway in this photograph, was originally open. This all-timber slip-housing was the first to be completed at Chatham in 1838. It is some 300 feet (91 m.) long and 146 feet (44 m.) wide, with a span of 62 feet (19 m.) over the slip, enabling ships to be built and repaired under cover. Chatham Royal Naval Dockyard was the last operational river yard; it closed in 1984.

Eric de Maré 1956

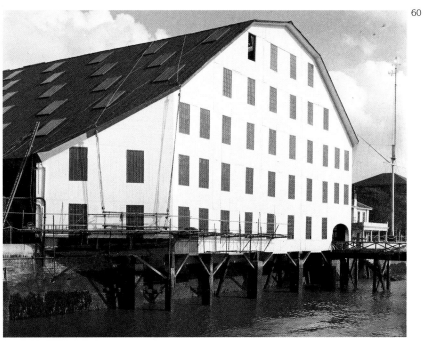

THE expansion of dock systems in the major ports throughout the 19th century was phenomenal. Liverpool docks spread from a nucleus near the town centre [61] to form a belt of docks some 7 miles (11 km.) long, while London saw a steady expansion, both east towards the sea [62] and on the Surrey side of the river, culminating in the opening of Tilbury docks in 1886 some 30 miles (48 km.) downstream. The Manchester Ship Canal acted in many ways as a 36 mile (57.5 km.) long dock, attracting industries to many points along its line as well as to its terminal wharfs in Salford.

61

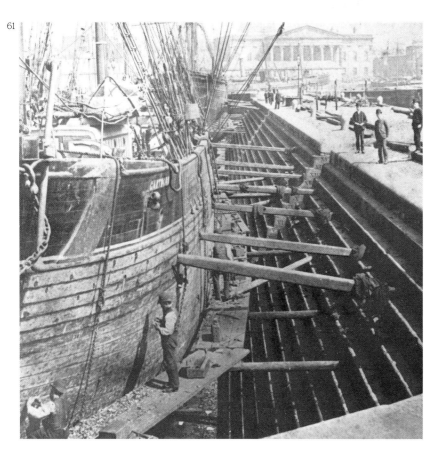

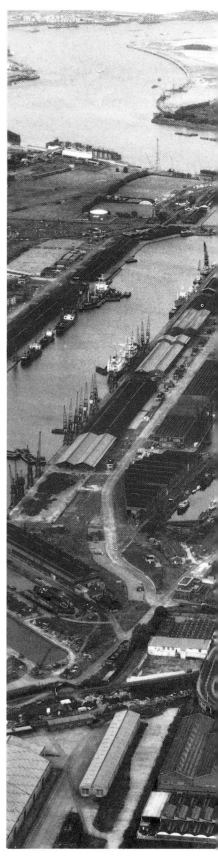

61 CANNING GRAVING DOCK (SJ 341899), SOUTH DOCKS, LIVERPOOL, MERSEYSIDE

The Corporation of Liverpool fostered the creation of the world's first mercantile dock system from the early-18th century. The two dry docks in this photograph, built 1765-9, were originally known as Nos.2 & 3 Graving Docks, where wooden-hulled sailing ships were repaired. They were renamed the Canning Graving Docks in 1840. Beyond the Canning Dock, 1829, in the background of this photograph is the Customs House in Canning Place on the site of the very first dock. The Customs House was built 1828-35 to the designs of John Foster the Younger. It was bombed during the Second World War and subsequently demolished.

Howarth-Loomes Collection 1860s

62 ROYAL DOCKS, NEWHAM, GREATER LONDON

The Royal Albert Dock (TQ425807), on the right of this photograph, was built 1875-80 to the designs of Sir Alexander Rendel. The King George V Dock (TQ430803), the penultimate dock to be constructed in the Port of London, was opened in 1921. This air view looking downstream also shows the Woolwich Ferry (*right*), opened in 1889; this was the first successful attempt to provide additional river crossings to the east of London. The paddle-steamers were replaced in 1963 and new terminals, designed by Husband & Company, were built in 1964-6. Woolwich Royal Arsenal is situated on the opposite bank.

RCHM 1980

RAILWAYS

WHILE the introduction of the steam locomotive was obviously a crucial stage in the success story of the railways, railed transport had as long a history before steam power as, in the event, it proved to have afterwards. Rails were certainly used in the 16th century in the mining districts of Shropshire, Nottinghamshire and the North East coalfield, but it was not until the late 18th century that metal replaced wood for both truck wheels and rails. By the end of the century two main types of rail were in use, namely edge rails which required flanged wheels and L-section rails which provided the flange themselves. The latter had a brief period of ascendancy during which some lines of appreciable length, such as the Peak Forest Tramway, were built.

By the time of the much-celebrated openings of the Stockton & Darlington Railway in 1825 and of the Liverpool & Manchester Railway in 1830, most of the features associated with railways had been in existence for some time on the various tramway

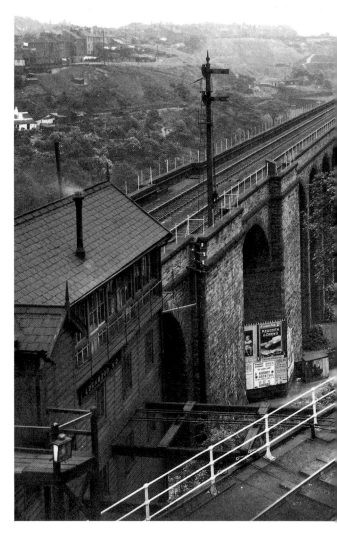

63 RAILWAY STATION (SX 965767), DAWLISH, DEVON

Brunel adopted the atmospheric principle of propulsion for the South Devon Railway and 26 miles (41.5 km.) were equipped between Exeter and Newton Abbot. The system operated by means of a piston which ran in an iron pipe laid between the rails and attached to the underside of the carriages. At intervals along the line, steam engines were erected which pumped the air from the pipe, thereby creating a partial vacuum which drew the piston and the train along the track. Trains ran by this method during 1847-8. Dawlish Station was opened in 1846 and this photograph shows the original station, which was destroyed by fire in 1873, and the Italianate tower of the pumping station beyond.

Howarth-Loomes Collection 1860s

63

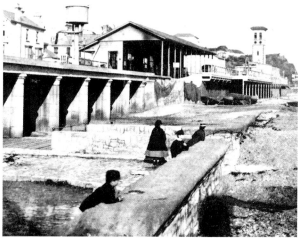

systems. They included, for example, structures such as the 103 ft. (40 m.) span Causey Arch of 1727 in County Durham, the Kings Mill Viaduct of 1817 near Mansfield and the Chapel-en-le-Frith tunnel of 1796 near Buxton. Organizational features of the railways had been presaged by the Parliamentary-sanctioned line of the Middleton Railways of 1758 near Leeds and by the public Surrey Iron Railway of 1803 from Wandsworth to Croydon. Even the use of steam locomotives had been anticipated on colliery lines on Tyneside from 1812 onwards. Many of the elements of a modern railway system therefore existed before the 1820s,

64 LOCKWOOD VIADUCT (SE 133147), HUDDERSFIELD, WEST YORKSHIRE

Railways serving Huddersfield had to contend with the three deep valleys at whose junction the town lies. The result was several spectacular viaducts and long tunnels. Lockwood Viaduct, one of the largest in Britain, stands 136 feet (41 m.) above the River Holme; it was completed in 1848 as part of the Huddersfield & Sheffield Junction Railway. The engineer, Sir John Hawkshaw, began his career as a road builder in his native Yorkshire. He built many railways in West Yorkshire following his appointment as resident engineer to the Manchester & Leeds Railway, but his most famous achievement was the construction of the Severn Tunnel for the GWR.

LMS Collection 1929

64

20th century to a total mileage of less than half that of the peak, the majority of lines closed were relatively late additions to the network. The most historic lines, by and large, have survived, some virtually unaltered. Thus, many of the structures on Robert Stephenson's London & Birmingham Railway appear today very much as depicted by J.C. Bourne in his famous collection of drawings published in 1839, while the former's magnificent High Level Bridge, Newcastle, and Royal Border Bridge, Berwick, of 1849 and 1850 respectively, carry modern inter city trains capable of speeds undreamt of by Stephenson himself. Ironically George Stephenson's pioneer Stockton & Darlington Railway of 1825 has fared less well, much of its line has been dismembered and few of the original structures remain in unaltered form.

In the second half of the 19th century the influence of the railway was all-pervasive. The unprecedented ease of movement of men and materials allowed massive concentrations of population and industry to develop, opened up new and distant markets for fresh produce and allowed suburbs to extend far beyond traditional urban areas of settlement.

The railways are also perhaps the most photographed of all industrial subjects. Their main period of construction coincided with the development of photography and as a result not only spectacular achievements but also shortlived experiments or expedients were recorded. Examples are the South Devon atmospheric railway and its distinctive stations [63] and the timber viaducts of the south west. The demise of features of the railway system is also lavishly covered by photographs with whole publications, not uncharacteristically loaded with nostalgia, devoted to signal boxes, hotels, goods sheds, stations, much else and, especially, steam locomotives [64-5].

through they did not yet make a convincing combination.

The Liverpool & Manchester Railway, however, with its conclusive demonstration of the potential of steam locomotive haulage, stimulated a transport revolution. Within the next two decades some 7000 miles (11,200 km.) of railway were built, involving a construction workforce of ¼ million men; by its peak early in the 20th century, the system consisted of a network of 23,000 miles (36,800 km.) of railway.

Although there has been a drastic contraction in the railway system in the second half of the

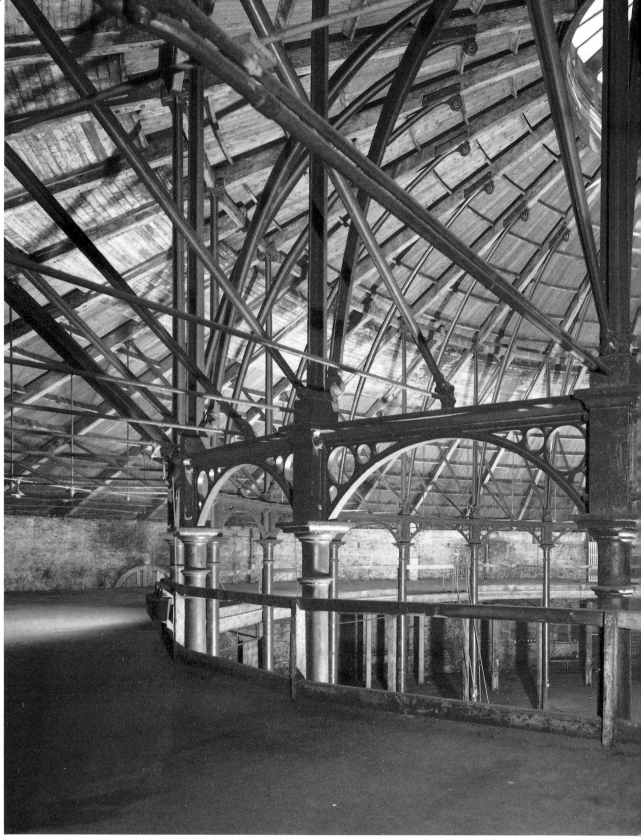

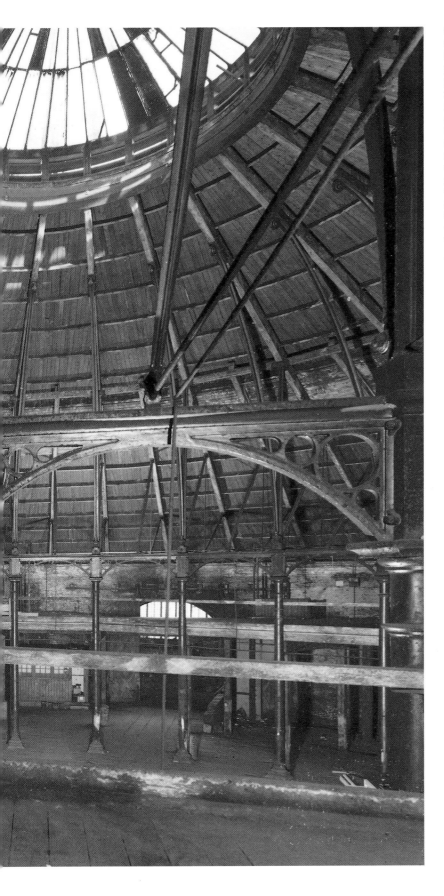

65 ROUND HOUSE (TQ 283843),
CHALK FARM ROAD, CAMDEN,
GREATER LONDON

Designed as an engine shed for the London &
North Western Railway by R.B. Dockray, with
Robert Stephenson as consultant, the Round
House was completed in 1847. Its life as an
engine shed lasted less than twenty years
because engines became too large to be
turned and stored there. In 1869 it was sold
and for nearly 100 years served as a bonded
warehouse for Gilbey's gin. This record
photograph is one of a series taken in 1964
when the future of the building was in doubt,
and shows clearly the impressive use of cast
iron. It has since been converted for use as a
theatre, for which its large area of
unencumbered space is well suited.

RCHM 1964

AVIATION INDUSTRY

THE aviation industry is wholly a 20th-century phenomenon with
such a rate of obsolescence that many of its historic sites, such as
Croydon Airport, have already either disappeared or changed use.
The airship hangars at Cardington in Bedfordshire do not perhaps
represent the mainstream of the industry's development and in any
case they date in their present from from 1926. They are, however,
once again the home of a British airship industry in which the 1980s
have shown a resurgence in interest [66].

66 AIRSHIP HANGARS, CARDINGTON, EASTCOTTS, BEDFORDSHIRE

These two immense structures, standing side by side, rise from the flat Bedfordshire landscape and dwarf everything for miles around. Both are important relics of the initially short-lived British airship industry. No.1 shed (TL 081469), on the left, was designed and built, 1916-17, by A.J. Main & Company of Glasgow for the Admiralty when it purchased the land for the construction of an airship works. The first two airships built in it were the *R31* and the *R32*. It was enlarged in 1926-7 by the Cleveland Bridge Company for the purpose of constructing and housing the *R101* by the Royal Airship Works. No.2 Shed (TL 082468) was built by the Cleveland Bridge Company in 1928 to house the *R100*, which had been constructed by the Airship Guarantee Company at Howden and arrived at Cardington in December 1929. The sheds are now in use again – for airships.

RCHM 1981

BIBLIOGRAPHY

Brian Bracegirdle, *The Archaeology of the Industrial Revolution.* Heinemann 1973.

R.A. Buchanan, *Industrial Archaeology in Britain.* Pelican 1980.

Neil Cossons, *B.P. Book of Industrial Archaeology.* David & Charles 1975.

Keith Falconer, *Guide to England's Industrial Heritage.* Batsford 1980.

Francis D. Klingender, *Art and the Industrial Revolution.* Edited and revised by Sir Arthur Elton, Adams & Mackay 1968 and Paladin 1972.

Arthur Raistrick, *Industrial Archaeology: An Historical Survey.* Eyre Methuen 1972 and Paladin 1973.

J.M. Richards, *The Functional Tradition in Early Industrial Buildings.* Architectural Press 1958.

Some of these general guides to the development of industry and its archaeology contain detailed bibliographies. Concise historical introductions to specific industries have appeared in the *Industrial Archaeology Series* published by Allen Lane, formerly Longmans, (1969-), and there are over 20 regional studies published by David & Charles (1965-) and Batsford (1978-).

General books on the history of photography are listed below. There are also a number of monographs on individual photographers, most notably Fox Talbot, Samuel Smith and Henry Taunt.

Brian Coe, *The Birth of Photography.* Ash & Grant 1976.

Helmut & Alison Gernsheim, *The History of Photography.* Thames & Hudson 1969.

B.E.C. Howarth-Loomes, *Victorian Photography.* Ward Lock 1974.

D.B. Thomas, *The First Negatives.* HMSO 1964.

INDEX